CUNARD

◆◈◆

Library

Out of respect for your fellow guests, please return all books as soon as possible. We would also request that books are not taken off the ship as they can easily be damaged by the sun, sea and sand.

Please ensure that books are returned the day before you disembark, failure to do so will incur a charge to your on board account, the same will happen to any damaged books.

The Essence of
Watercolour

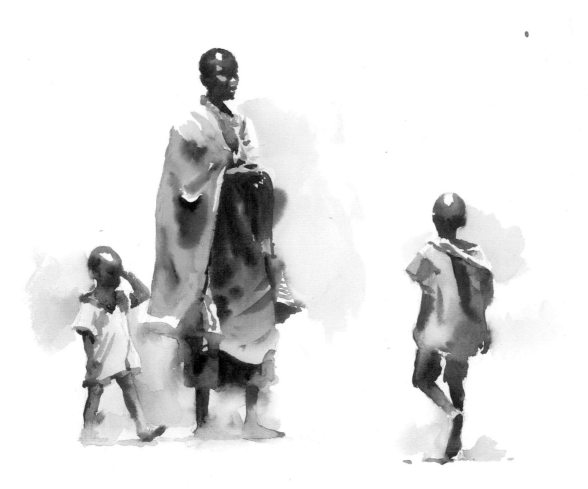

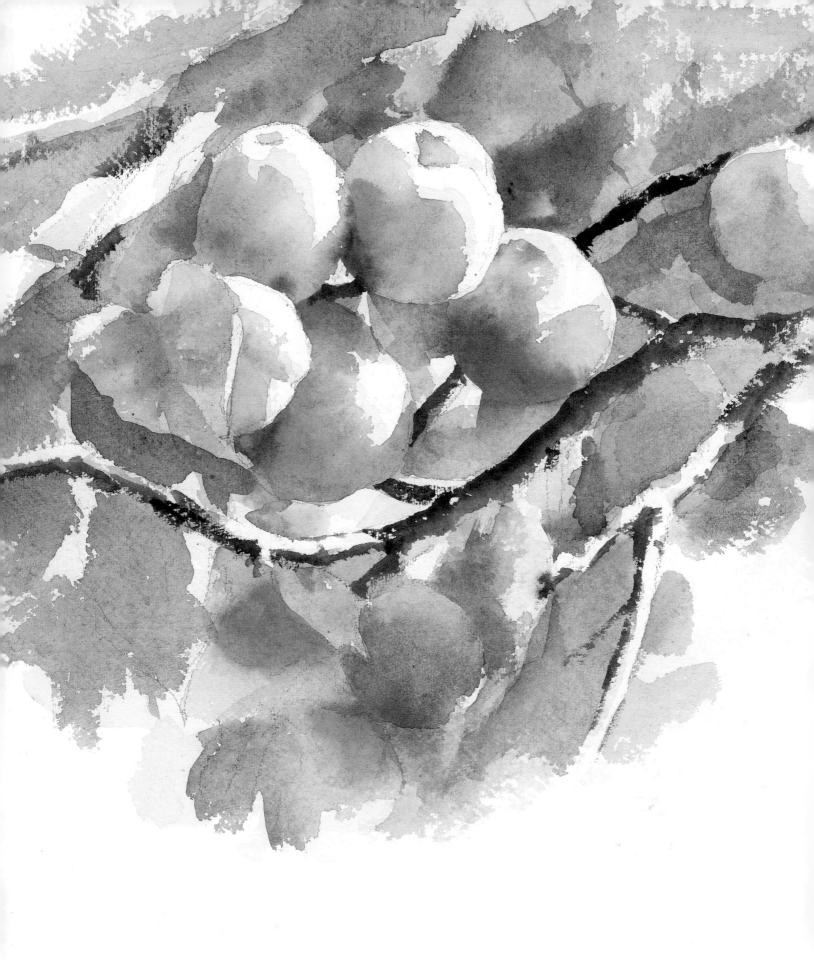

The Essence of Watercolour

Hazel Soan

Page 1: Belonging
33 x 25 cm (13 x 10 in)
Watercolour is the perfect medium
for capturing moments in time.

◁ **Ripening in Tuscany**
30 x 30 cm (12 x 12 in)
The organic colours and overlapping tints
of watercolour breathe life into the apricots
ripening on the tree.

BATSFORD

Dedication: To all my readers.

Acknowledgements: Huge thanks go to Cathy Gosling for her faith in my writing and to Kristy Richardson who has been a joy to work with. Thanks go to Winsor & Newton for responding to my questions so effectively. Thank you also to Angela and Janice for their help and to Lorraine McCreery for the photo reference on page 100. A special thank you to my husband and son for their love.

First published in the United Kingdom in 2011 by
Batsford
10 Southcombe Street
London W14 0RA
An imprint of Anova Books Company Ltd

ISBN-13: 9781906388737

A CIP catalogue record for this book is available from the British Library.

10 9 8 7 6 5 4 3 2 1
20 19 18 17 16 15 14 13 12 11

Reproduction by Rival Colour Ltd, UK
Printed and bound by 1010 Printing International Ltd, China

This book can be ordered direct from the publisher at the website: www.anovabooks.com, or try your local bookshop.

Distributed in the United States and Canada by Sterling Publishing Co., 387 Park Avenue South, New York, NY 10016, USA

Designer: Caroline Hill
Copy Editor: Geraldine Christy
Photography: Madeleine Stone

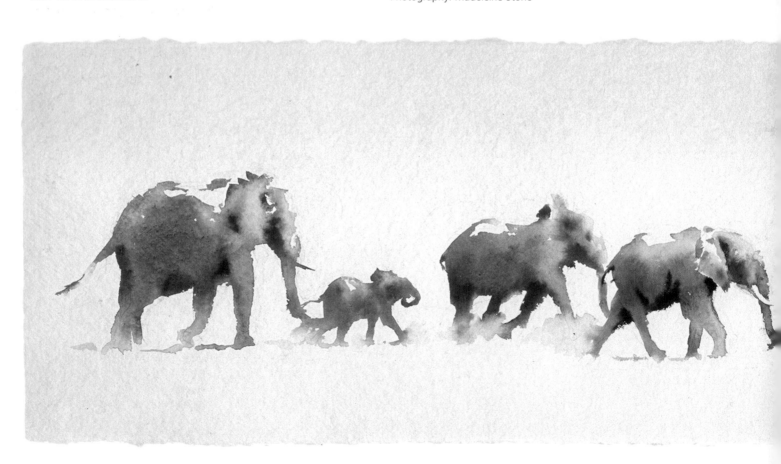

Contents

Wild Intervals
25 x 102 cm (10 x 40 in)
Watercolour can suggest so much
within its gentle evocative blends.

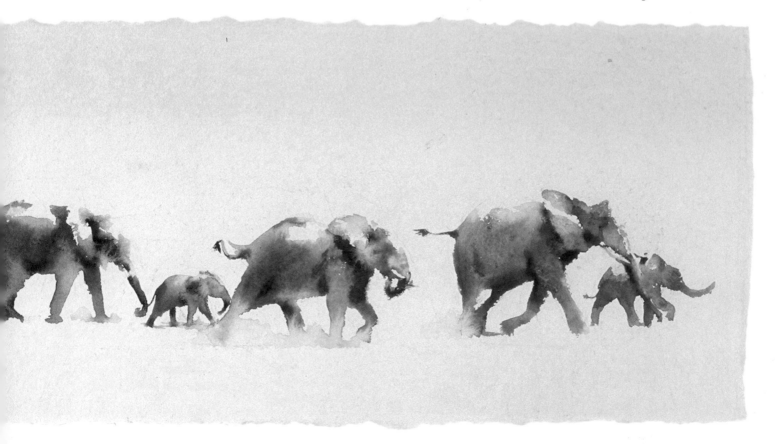

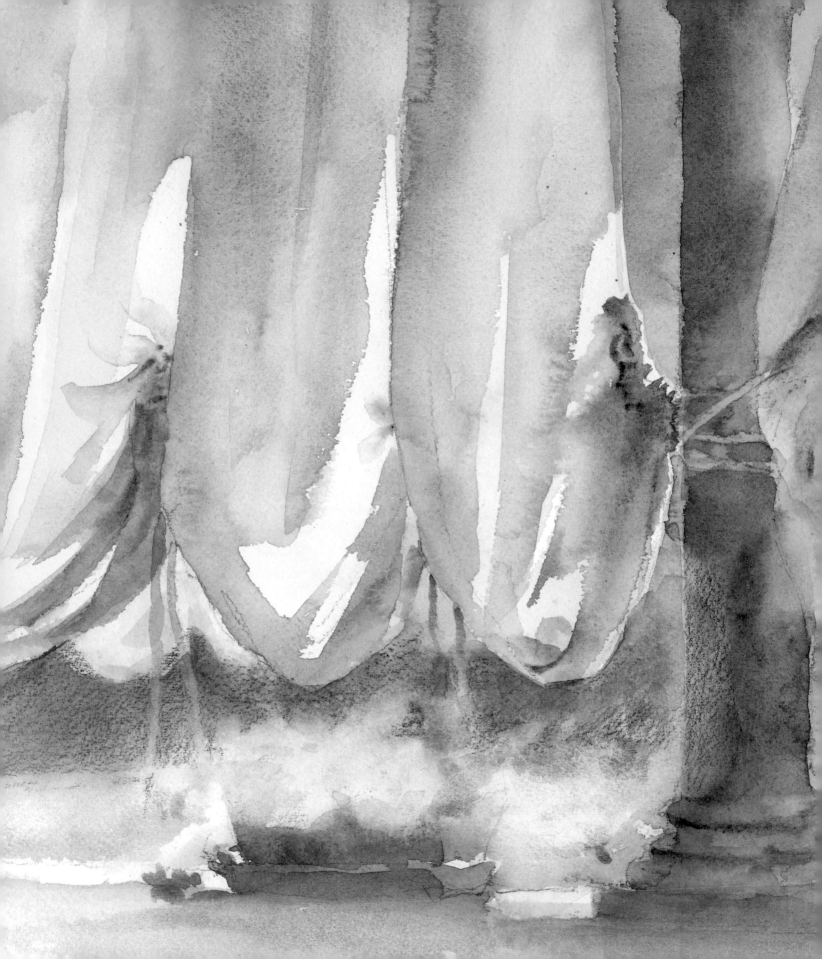

The Appeal of Watercolour

It is easy to see why watercolour is so appealing. The brilliance of the pigments, the transparency of the colours, their exotic names, and the infinite variety of radiant blends, combine to offer a medium of unsurpassed quality. Mixed with water, laid on paper, easy to carry, and quick to apply, watercolour is supremely practical for anyone wanting to paint. Shimmering light and delicious darks are the province of watercolour, adding to the joy of working with such a satisfying medium. All these qualities are the distinctive characteristics of this versatile medium. They give it a unique identity and are the essence of watercolour.

Sunlight bathes the Cloisters
35.5 x 51 cm (14 x 20 in)
The transparent, radiant tints of watercolour convey light with a mystery hard to emulate in other painting media.

A Captivating Medium

The more I paint with watercolour the more impressed I become with the medium. Its intrinsic beauty, and the brilliance, radiance and transparency of its pigments, seem to offer more than the opportunity to make paintings of breathtaking beauty. Choosing the pigments, brushes and paper is an aesthetic experience in itself; mixing colours in the palette is immensely satisfying; making brushmarks is a thrill; and even watching paint dry becomes a fascination as the flowing colours blend. Researching the science of watercolour's action on paper for this book has made me fall in love with the medium even more! So perfectly suited to its purpose, the less you order it around the more ably it performs, and the more you put your trust in the materials the finer the reward.

Shoes With Attitude
51 x 51 cm (20 x 20 in)
Watercolour has the ability to transform something ordinary – even these shoes – into something magical. The transparent, fresh, brilliant colours makes this lovely medium so appealing.

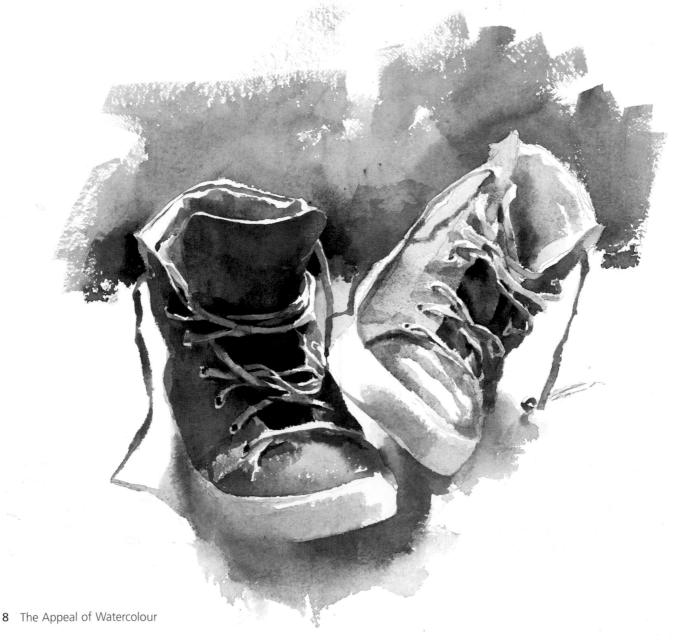

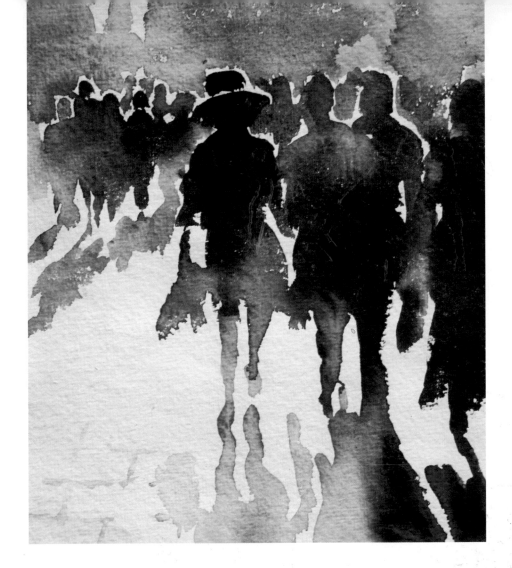

Lay it and Leave it

Yet, with all these benefits watercolour remains a very challenging medium. When confronted with a sheet of white paper there is often fear in the first brushstroke, the adrenaline pumps, the stomach churns, anxiety is high. Why?

Unlike oils or acrylics, watercolour is essentially a kinetic medium – the wet pigments move on the paper. This means the painter may not always feel, or be, in control of the medium and this can be intimidating. Once you understand what might happen, however, you can harness this action and encourage it to head in the direction you desire. Soon you will trust the perfected pigments, silky sables and tactile papers to uphold their promise, and the results reflected in your paintings will increase your confidence.

Watercolour welcomes decisiveness, it does not really like prevarication. My motto has become 'Lay it and leave it'. Plan the painting, mix the pigment, lay the brushstrokes and then leave the watercolour to work its own magic on the paper. This is the essence and art of watercolour painting.

A Big Hat in Oxford Street
15 x 15 cm (6 x 6 in)
The gentle diffusion of colours, the untouched white paper for the highlights, and the irregular edge to the brushstroke, are three of watercolour's most-loved characteristics.

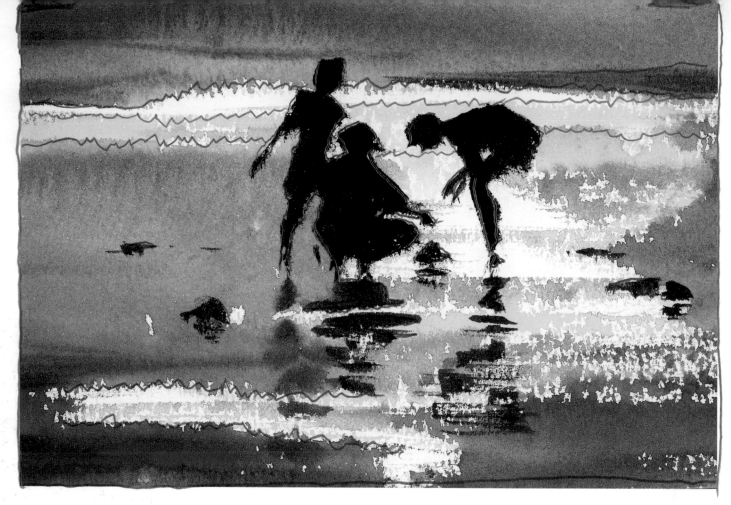

Castles in the Sand
13 x 18 cm (5 x 7 in)
Many of the delightful effects of watercolour
occur after the brush has left the paper.

Full of Surprises

Watercolour often surprises. It is not an exact science. The artist sets the painting in motion, but the outcome is not certain. The watercolour takes on a life of its own and anything can happen. Sometimes the result surpasses the artist's hopes, but there is also the risk of failure – this is all part of the thrill. The aim of this book is to help you gain confidence through greater knowledge of what you can expect from this remarkable medium. To encourage you to exploit the properties of watercolour to the full and to make you less afraid of strength of colour and brazen brushstroke, practise the techniques using the 'Explore' spreads at the end of each chapter. Knowing how to achieve clarity, transparency and radiance will put you in the driving seat.

Fynbos (detail)
7.5 x 10 cm (3 x 4 in)
Salt dropped into a wash creates delightful
patterns as the water evaporates.

The Thrill of the Chase

My understanding of how watercolour behaves is gleaned through many years of practice, and I am still learning. I do not believe I can conquer this medium and it is that challenge that keeps my adrenaline running high when faced with a sheet of white paper. Almost every painting I make is an experiment, a chance to find out something more about watercolour. I love this medium. I love the intense concentration it demands, the bliss of being totally caught up in the painting, the lure of such beautiful colours, such sensuous brushes, such tempting paper. For me the time spent mixing in the palette, waiting for the right moment to add even the tiniest touch of pigment is just as exciting as making the brushstrokes on the paper. The finished result is no more important than the joy of the painting process.

Valetta
25 x 35.5 cm (10 x 14 in)
The immediacy of blended colours could be ruined if this painting was taken any further, even though in my planning it had only just begun! The medium of watercolour is so dynamic that a painting can be considered 'finished' at any stage.

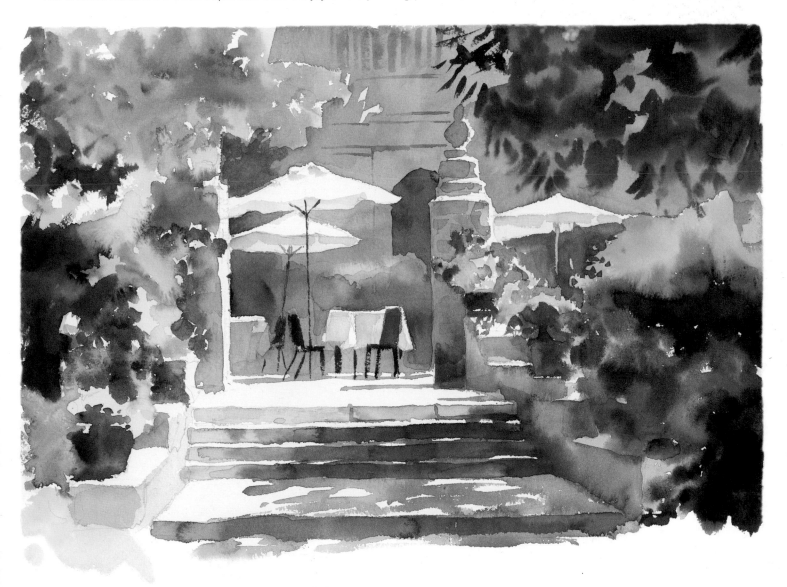

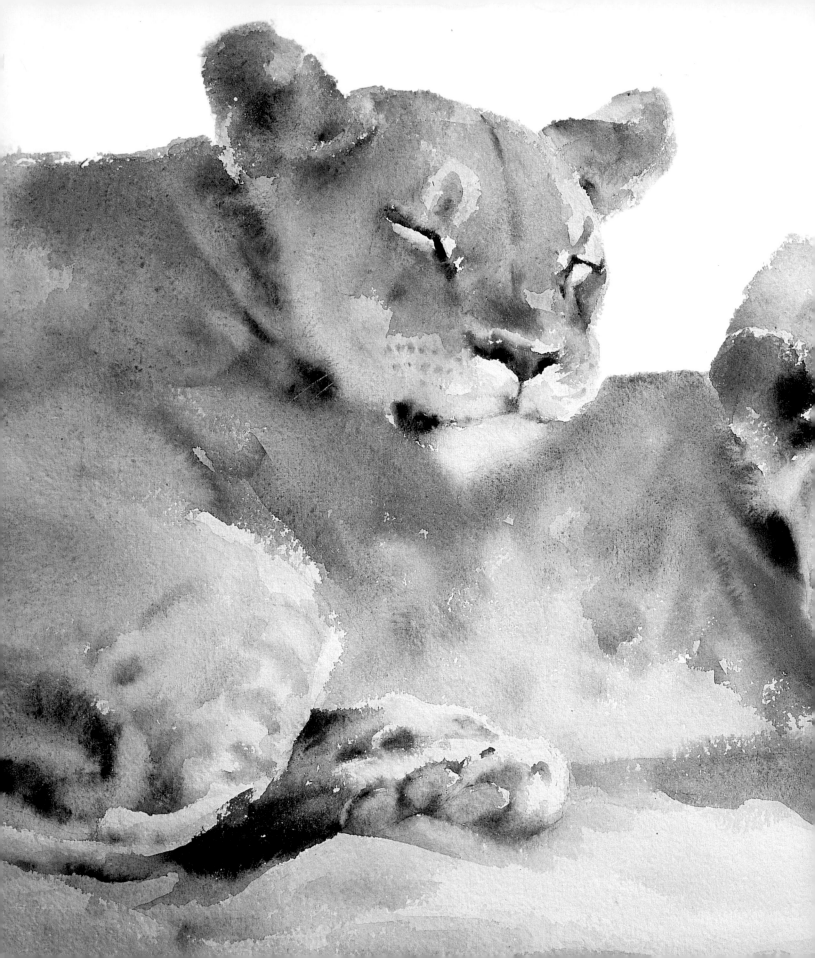

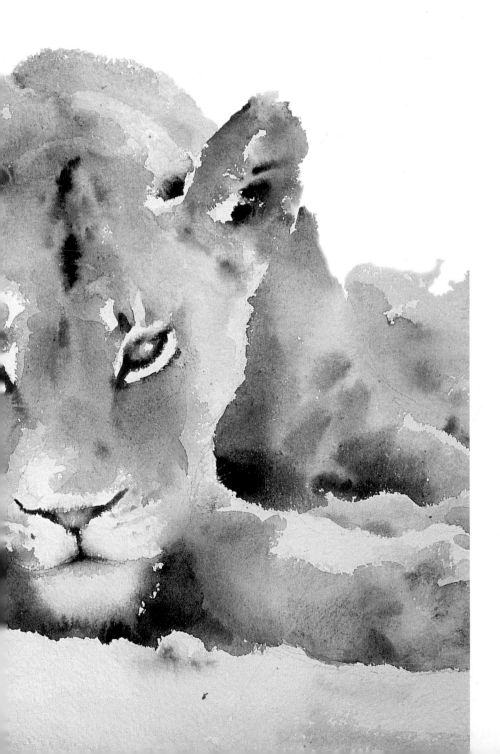

1 Being Transparent

The transparency of watercolour
is its most intriguing asset. Rich,
exotic pigments, diluted with water
and laid on paper, glow as if light
itself emanated from the myriad hues.
There are dozens of jewel-like colours
to choose from, each with different
levels of transparency, and the white
of the paper offers a light-reflecting
background to add to their brilliance.
The sheer variety is a treasure-trove
for the artist, but can also lead
to misapplication and confusion.
Learning how to use these properties
to your advantage is the intended aim
of this chapter – to make
transparency, transparent!

Sleeping Lions
56 x 76 cm (22 x 30 in)
Transparent watercolour bestows a warm
glow on these lionesses dozing in the shade.

Resonant Pigments

Watercolours are made by combining finely ground pigment with a binder, usually gum Arabic from the acacia trees of Africa. When the artist adds water the binder dissolves, carrying the particles of pigment in suspension and enabling the painter to spread colour freely across the paper. The water evaporates and the gum dries, providing adhesion for the pigment upon the surface and allowing the artist to apply layer upon layer of resonating colours without disturbing the colours underneath. Light shines through the pigment layers and is reflected back from the white paper, creating an extraordinary and unique radiance. Some of the pigment particles also cause refraction of the light, adding to the luminosity.

The radiance of watercolour is apparent even in the palette. Here the transparent colours Prussian Blue, Indian Yellow, Aureolin, Permanent Rose and Winsor Violet mingle together to make a wealth of secondary hues.

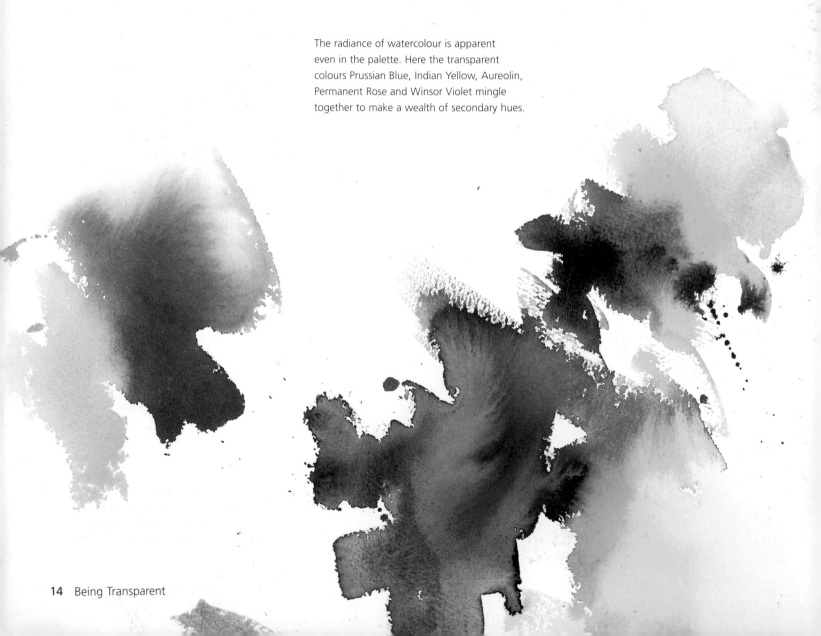

Transparent or Opaque

All watercolours are transparent when diluted with water, but some are less transparent or even opaque in their concentrated form. The transparent pigments remain transparent however thickly they are mixed. They are bright and clear and can be overlaid in successive glazes without losing transparency. They can be mixed together without losing clarity and, in concentration, form deep, clear darks.

The opaque colours are strong or brilliant in hue and have great covering power. They can be used to add brilliance to a wash or change the tone of a picture. Their opacity in a dense form means they can override darks and restore areas of light. Because they are opaque they will lessen the transparency of a mix and reduce transparency in layering, so if misused they can cause dull or muddy colour.

To get to know the properties of a colour, rinse off small amounts from the brush in a jar of clean water – transparent pigments will tint the water, opaque pigments will turn it cloudy.

△ The transparent colours Ultramarine Blue, Permanent Rose and Aureolin can be overlaid and continue to maintain transparency.

◁ Many of the vibrant pigments made from metal particles – for example, Cadmiums Red, Orange and Yellow, Cobalt Blue, Cerulean Blue and Manganese Blue – are opaque.

Brilliance and Radiance

Radiance requires the gleam of reflected light, so a transparent colour is better able to deliver the most radiant hues. The opaque colours, especially the Cadmium colours, are renowned for their brilliance and brightness of colour and therefore supply the most brilliant hues. Since all colours in their dilute form are transparent it is only when it comes to tinting and layering that you have to be aware of transparency or opacity. Good quality artists' watercolours use a letter code to indicate how a colour will perform: T (Transparent), ST (Semi Transparent), SO (Semi Opaque), O (Opaque).

▷ **The Race Is On**
40.5 x 35.5 cm (16 x 14 in)
The opaque colours Cadmium Red, Cadmium Yellow and Cobalt Blue deliver brilliant hues.

▽ **By Any Other Name**
15 x 20 cm (6 x 8 in)
The radiance of a fragile rose is matched by the radiance of three transparent watercolours, Indian Yellow, Permanent Rose and Prussian Blue.

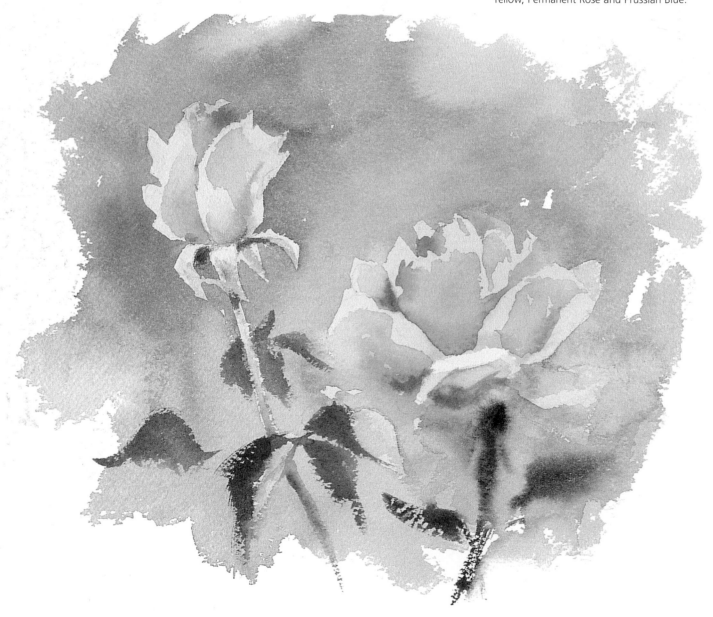

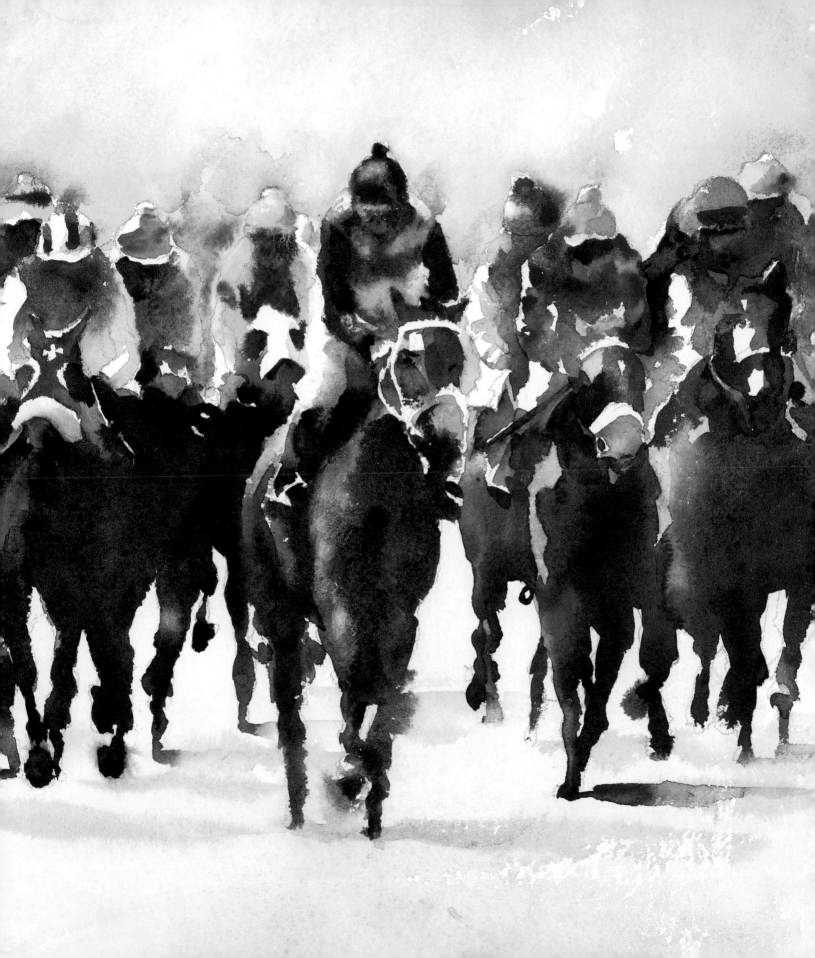

Layering Colour

Watercolours can be made up of successive layers of transparent colour, creating a wider variety of tones and hues from very few colours. Subtle and vibrant secondary and tertiary colours are created from overlapping layers, often having a more luminous appearance than if the colours were mixed together in the palette.

 The amount of water and the transparency or opacity of the overlaying colour determines how much it alters the undertone. The order of application also varies the resulting colour – thus a green created from a blue over a yellow will differ in hue from the same yellow painted over the same blue. This difference is even more noticeable when layering with opaques as they have more covering power.

In Advance of a Vegetable Soup
35.5 x 46 cm (14 x 18 in)
Radiance in the first layers of a watercolour is a portent for the success of the finished painting. Just a few colours were chosen to make the painting, but the overlapping washes make many more hues and tones.

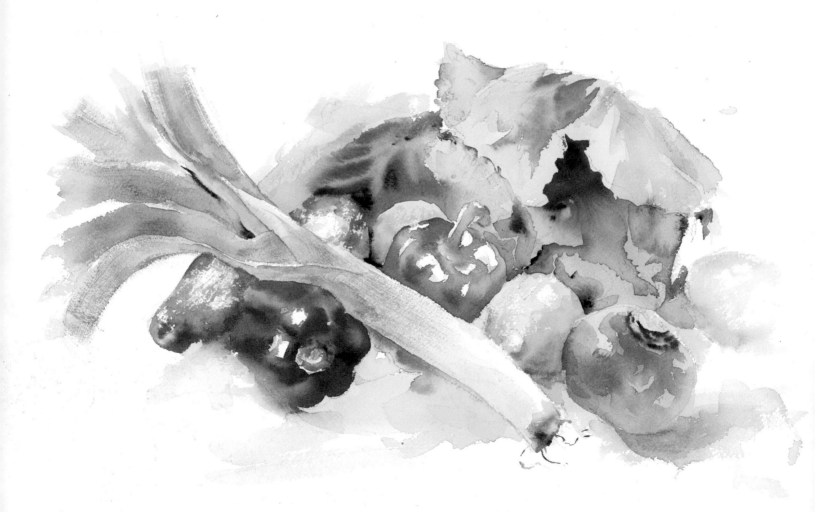

Myriad Hues and Tones

Building in transparent layers creates a myriad of subtle hues and tones across the painting: ideally no layer covers the exact same area as a previous one and some charming effects are created by leaving certain parts of a preceding wash untouched by the next.

If your first wash turns out to be a timid version of an intended colour, leave something of the undertone untouched by the next and it will not be wasted.

Staining

The pigments of many watercolours stain the paper and cannot be lifted off. These are particularly good for making transparent tints as their colour cannot be disturbed by successive layering. Staining colours are rated with the code ST, and include modern organic colours and traditional pigments such as Prussian Blue, Alizarin Crimson, Aureolin and Permanent Rose.

The Hills Are Alive
10 x 20 cm (4 x 8 in)
The staining property of Prussian Blue makes it an ideal choice for successive layers of colour in this sketch of receding hills beside an Italian lake.

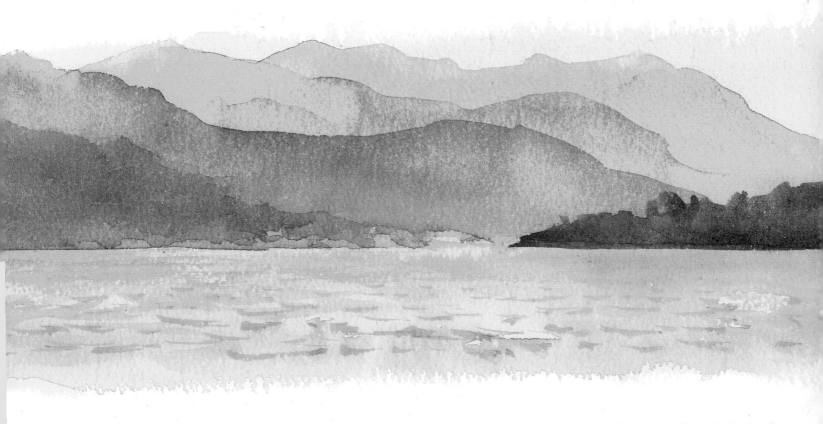

Watching Paint Dry

To ensure unsullied transparency the underlying colour must be completely dry before another layer is brushed over the top. This is of paramount importance and may require the utmost patience. This point cannot be emphasized enough; impatience has ruined many promising watercolours.

The best way to check paint is dry is to view the paper from an angle where the light shines on the surface – if it is damp it will shine, if it is dry it will be matt. If the paper is buckled then the watercolour is also probably still drying. Avoid the temptation to touch your paper to check how dry it is; firstly you will disturb the settling pigment if it is not, and secondly, if it is, you will be transferring grease from your finger to the paper.

Be sure the paint is dry and then wait a little longer: much of a watercolourist's life is truly spent watching paint dry!

Slumber
30 x 40.5 cm (12 x 16 in)
The lioness's head is constructed with layers of transparent colours. Successive brushmarks of dilute Yellow Ochre and Prussian Blue were only applied when previous layers were dry, thus keeping the washes undisturbed and the colours clean.

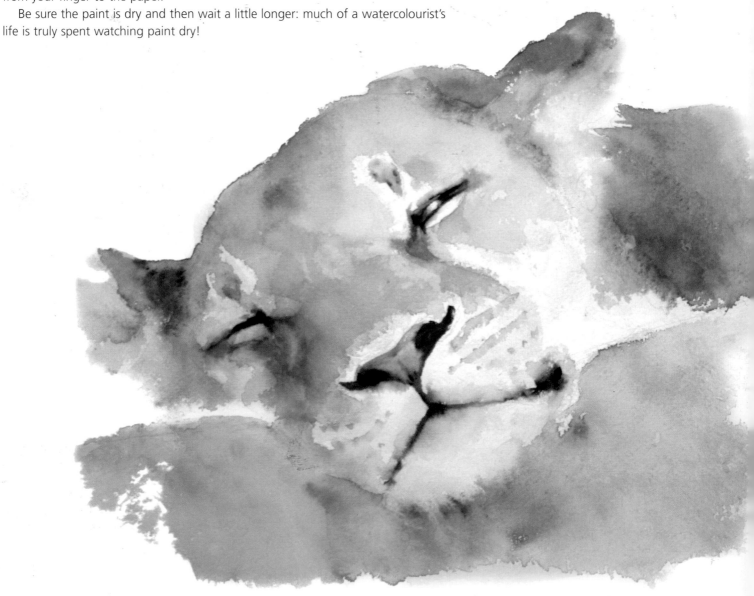

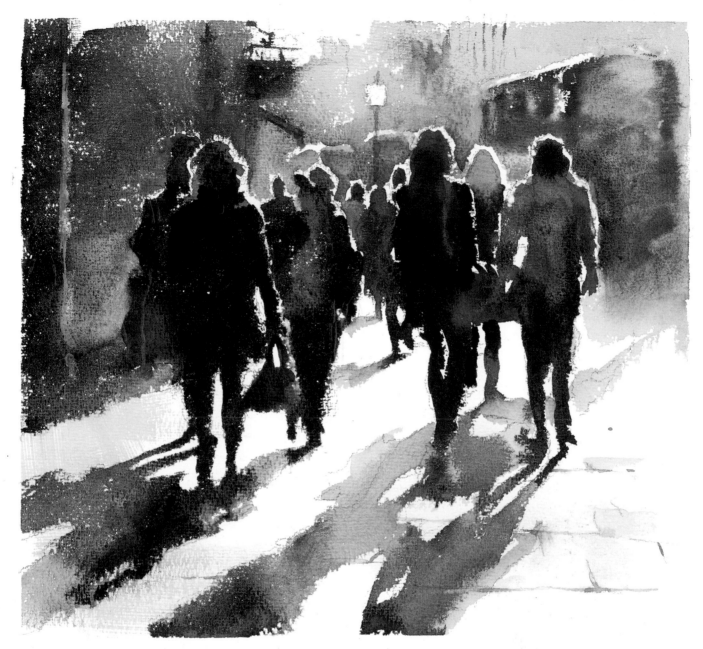

Maintaining Transparency

Too many layers of paint will eventually kill off transparency, as light no longer
permeates, so it pays to spend time mixing colours in the palette and to be decisive.
Avoid the tendency to strengthen or darken a tone by applying repetitive layers of
dilute paint as this has the effect of deadening colour rather than deepening it.
The vibrant transparency of the initial wash on the white paper is used to great
advantage by the wet–in–wet technique of adding colours to the wet paint and
allowing them to mingle in a single layer on the paper. This technique is discussed
in depth in the next chapter.

Regent Street
30 x 30 cm (12 x 12 in)
In this street scene Indigo, Sepia, Cadmium
Red, Indian Red and Cerulean Blue, all opaque
pigments, remain vibrant and transparent in a
single layering of the colours.

Red, Yellow and Blue

Using a few colours is the surest way to learn about colour and guarantees harmony in a painting. In the Winsor & Newton range the three 'primaries' are classed as Winsor Lemon (ST), Winsor Blue (T) and Permanent Rose (T). This trio includes two transparent paints and a semi transparent/opaque one, which is a good rule of thumb for a threesome. Choose any three colours that lean towards a red, blue and yellow to make versatile colour combinations. Overlay or blend the transparent tints to make interesting secondary and tertiary colours. Do not be afraid to use transparent colours brazenly; if you end up with garish colour you can easily mute it by applying a tint of the opposite colour.

Choosing Your Palette

To ensure transparency in your watercolours err on the side of using the transparent colours. For example, if you normally use Lemon Yellow (O) and Cadmium Yellow (O) swap them for Aureolin (T) and Indian Yellow (T) to make transparent foliage greens. Save the opaques for pulling punches of brilliant colour, blend them wet-in-wet, or use them for adding highlights. Familiarity with the colours is an integral part of painting. Limit your choice to around twelve colours and get to know them well.

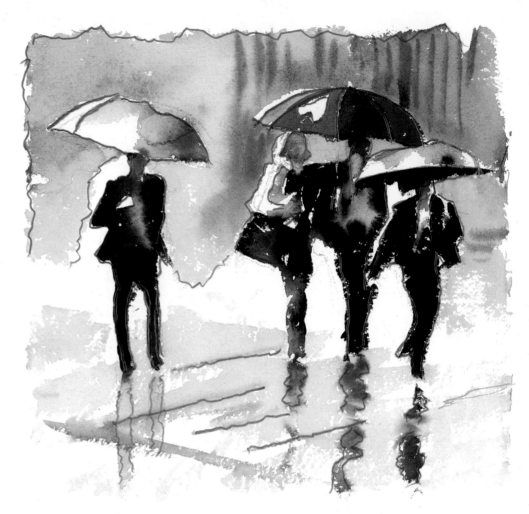

Brollies at the Bank
30 x 30 cm (12 x 12 in)
Versions of a blue, red and yellow – here, Prussian Blue (T), Cadmium Red (O) and Raw Umber (T) – make a happy combination of three colours. The blue and red mix together to make a lovely black.

Caput Mortuum Violet (O)

Permanent Mauve (T)

Ultramarine Violet (T)

Cobalt Violet (ST)

Warm Orange (T)

Cadmium Orange (O)

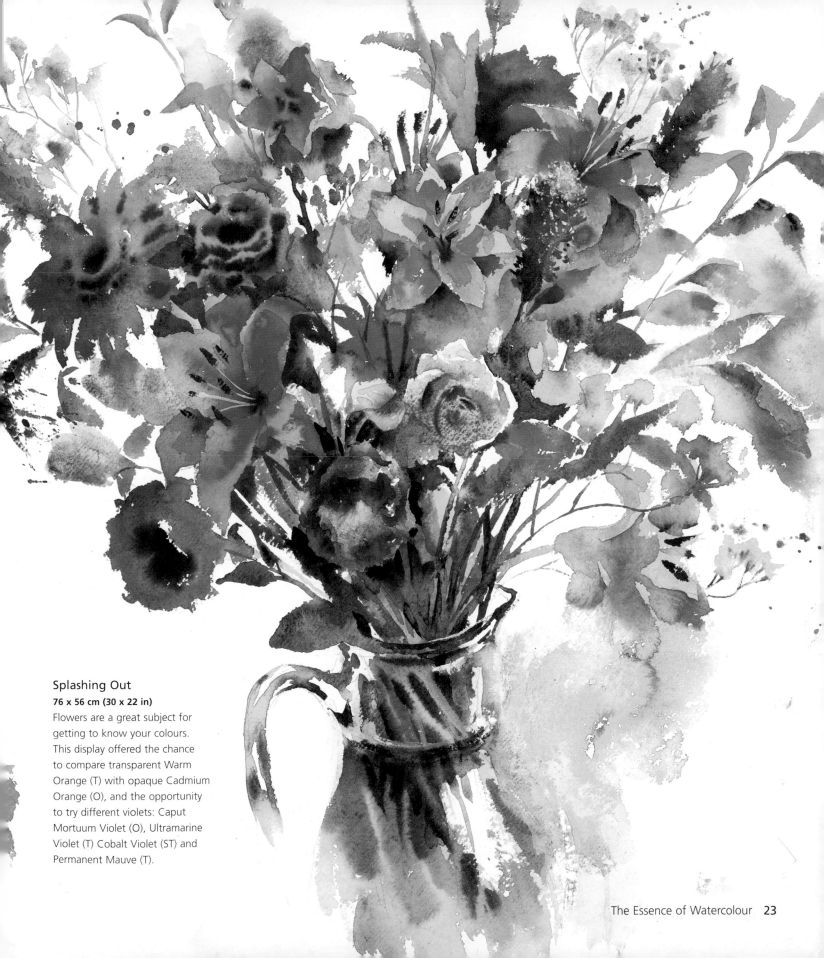

Splashing Out
76 x 56 cm (30 x 22 in)
Flowers are a great subject for
getting to know your colours.
This display offered the chance
to compare transparent Warm
Orange (T) with opaque Cadmium
Orange (O), and the opportunity
to try different violets: Caput
Mortuum Violet (O), Ultramarine
Violet (T) Cobalt Violet (ST) and
Permanent Mauve (T).

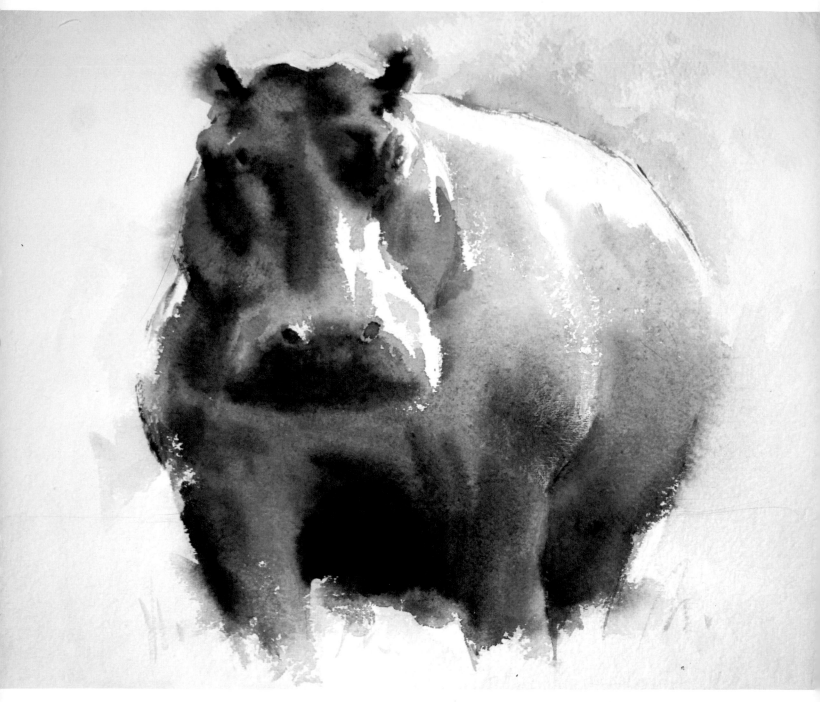

Big Hippo

56 x 71 cm (22 x 28 in)

To trap the heat in this painting the hippo
was painted with warm and cool reds, plus
a warm blue and warm brown. The colours
were Cadmium Red, Alizarin Crimson,
Ultramarine Blue and Burnt Umber.

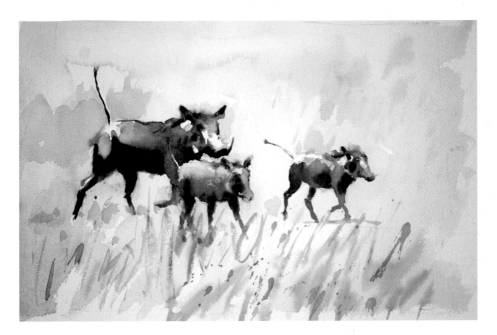

Tails in the Air
23 x 30 cm (9 x 12 in)
The warthogs, with their predominance of Prussian Blue, appear much cooler in colour temperature than the hippo in the painting opposite.

The Temperature of Colour

Colours are affected by their colour bias, known as colour temperature – warm colours veer to red, cool colours lean to blue, or red's opposite colour, green. The way colours are described indicates their hue and their colour bias, so Alizarin Crimson is deemed a cool red because it is a red hue veering towards blue. Ultramarine Blue is a warm blue because it leans towards red.

To make the brightest mixtures and to produce the clearest layering of transparent tints, combine colours of the same temperature. Thus a bright orange could be made with a warm red (Cadmium Red) and a warm yellow (Indian Yellow). A bright green could be made from a cool yellow (Aureolin) and a cool blue (Prussian Blue).

Since mixing or overlaying colours of like bias gives you the brightest version of a colour, so it follows that more subtle colours are achieved by mixing or overlaying colours of opposite bias. A combination of a cool and a warm colour means a measure of each of the three primaries has been included in the mix. This is especially helpful when mixing foliage greens – for instance, Prussian Blue (cool) and Burnt Sienna (warm) make a delicious, non-garish, transparent green.

The colours I use regularly are listed below. Most of them are transparent and there is a cool and warm version of each of the primary colours.

COOL COLOURS	WARM COLOURS
Aureolin (T)	Indian Yellow (T)
Alizarin Crimson (T)	Cadmium Red (O)
Prussian Blue (T)	Ultramarine Blue (T)
Permanent Rose (T)	Yellow Ochre (SO)
Winsor Violet (T)	Burnt Sienna (T)
Indigo (O)	Raw Umber (T)
Sepia (O)	Burnt Umber (T)

Make the veins appear by omitting them from the second layer.

EXPLORE!
Transparent Layers

Shape the leaf with the background wash.

Paint the many petals with overlapping brushmarks.

Paint the stem of leaves by layering brushstrokes.

Try using modern carbon pigments to maintain transparency in successive layers of red.

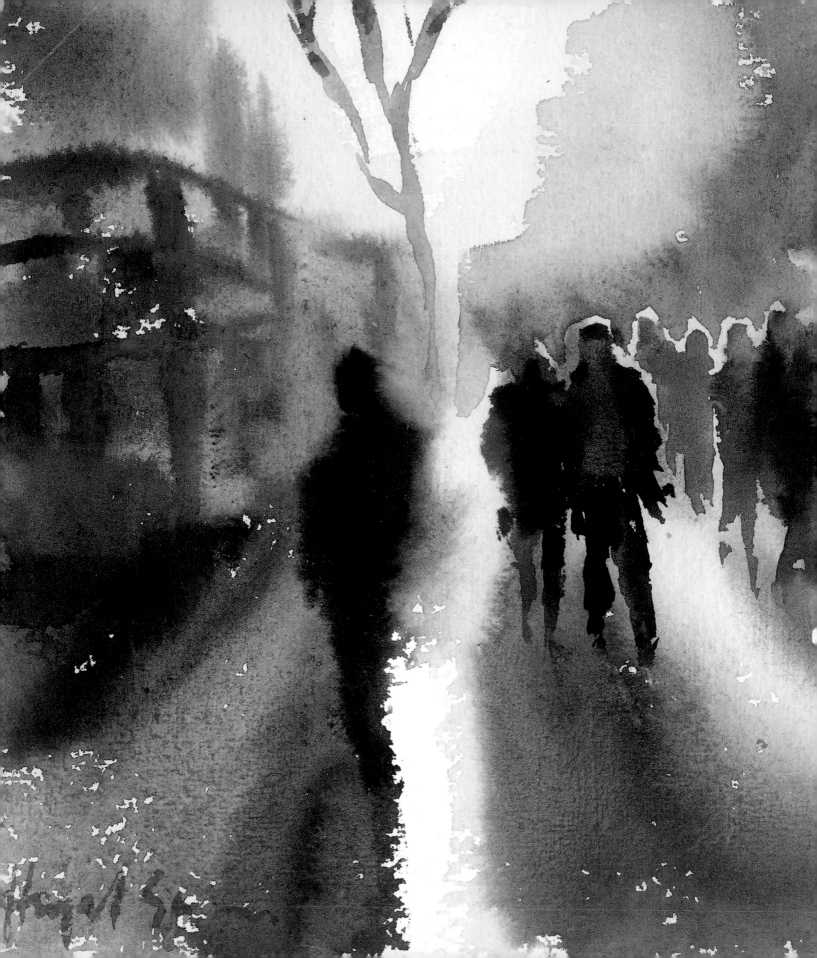

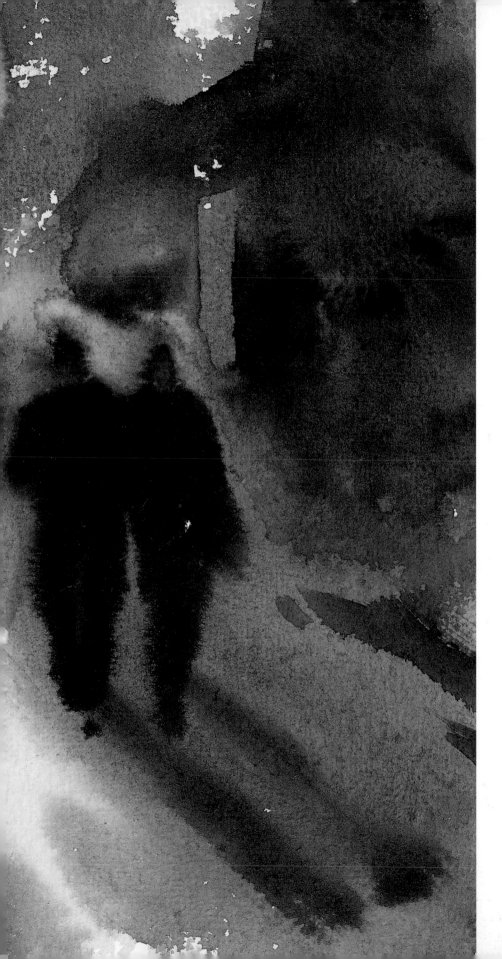

The Fusion of Colour

Watercolour is renowned for its delicious passages of blended colours. As two colours meet and merge new colours are born and the dividing line between them blurs. Mystery lies in these blends — the artist may lay on the colours, but as the colours mingle there is always an element of surprise, and glorious things can happen. Herein lies creation: that which the artist sets in motion takes on a life of its own and produces something unexpected. It is this that makes watercolour such an exciting and truly creative medium to use and to behold.

Vibrant City
23 x 30 cm (9 x 12 in)
Here the colours were added in the order of the spectrum, creating other hues and shades as they mingled.

Blending Colours

The action of blending watercolour on paper is termed wet-in-wet technique. Beautiful effects are created as different pigments intermingle. Colours must be well mixed in the palette and not too watery. The first colour is laid and the other colour or colours are added beside or into it while the first is still wet. This results in the pigments blending on the paper, creating new and undetermined colours where the two meet and merge.

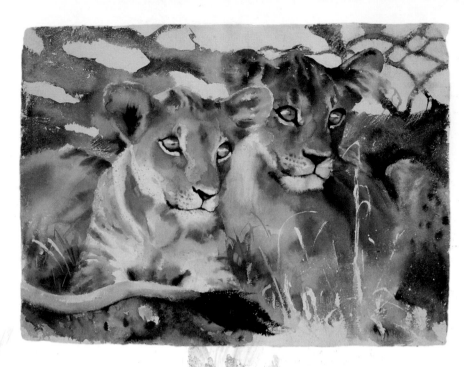

▽ **Wild Clash**

51 x 76 cm (20 x 30 in)

Very wet washes of Raw Umber, Burnt Umber and Prussian Blue were blended together on rough khadi paper to describe the rounded forms of the sparring elephants. Winsor Violet was added, undiluted, for the darks.

△ **Young Ones**

56 x 76 cm (22 x 30 in)

Lovely blends are achieved with wet-in-wet technique as higher concentrations of Burnt Sienna and Winsor Violet diffuse into the lower concentrations of dilute Yellow Ochre and Prussian Blue.

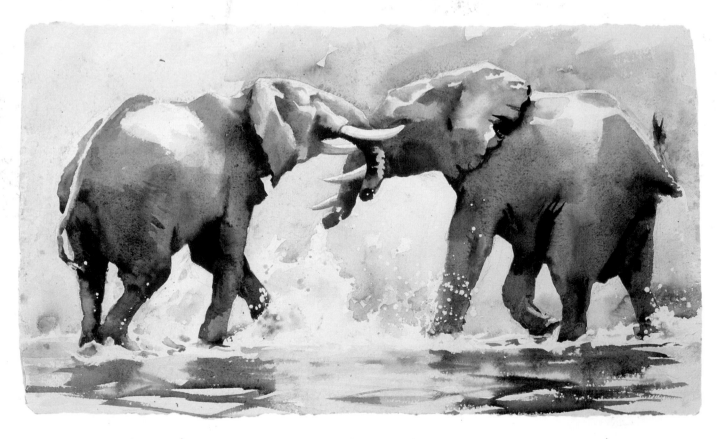

Taking Control

Imagine what is physically happening here. The pigment grains suspended in the solution of gum Arabic and water spread outwards into the first wash, mingling together where they meet to create a third colour. The amount of water mixed with the pigment determines how far one colour travels into the other – plenty of water and the colour will run a long way into the first wash; little water and it will barely move. This is where the control of the artist comes in. If you want the added colour to spread a long way into the first wash make a wet mixture; if you wish to prevent spreading use little or no water. You have control over the distance the added wash will travel simply by altering the amount of water in your mix.

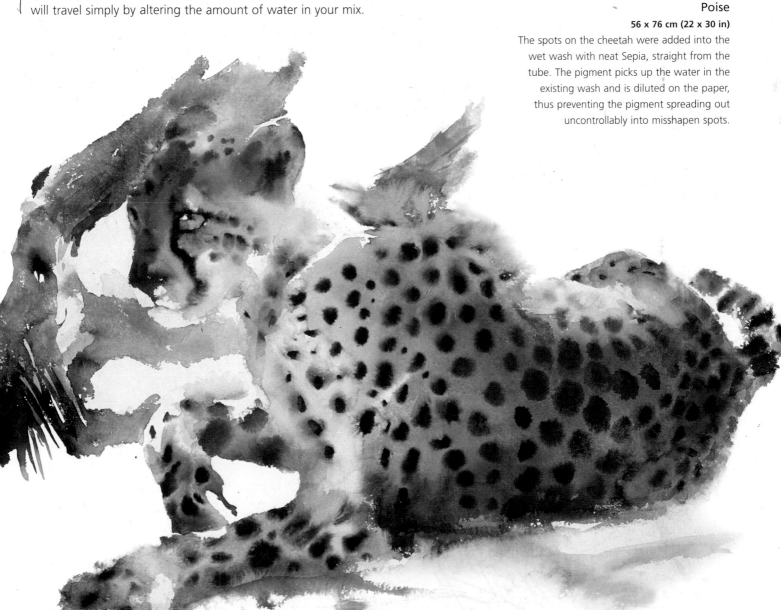

Poise
56 x 76 cm (22 x 30 in)
The spots on the cheetah were added into the wet wash with neat Sepia, straight from the tube. The pigment picks up the water in the existing wash and is diluted on the paper, thus preventing the pigment spreading out uncontrollably into misshapen spots.

Timing

Timing is everything. If the first wash is very wet the new wash will spread far into the first; if it is almost dry it will not move out at all. Once drying occurs the pigment granules settle evenly into the topmost layer of the paper and are fixed in place by the gum Arabic so that blending can no longer occur. Disturbing the pigment grains as they are about to dry will result in uneven washes, and ... mud. Think of the pigment particles as pixels, all settling neatly on the paper in random but orderly spacing. If you go in and disturb them as they are drying they will bunch up into clumps and lose their even lie.

◁ **Jesus Bird**
20 x 28 cm (8 x 11 in)
The underside of the bird's belly was touched into the damp Burnt Sienna wash with very concentrated, almost dry, pigment to ensure the colour remained strong as it picked up water from the previous wash.

Intensity

The secret of blending colours is to go in early with the second wash or colour as soon as you can, before drying can take place, and control the outward spread by limiting the amount of water in the added wash.

There is already water on the paper once the first wash is laid, so you need less water in the second wash. Add the second wash while the first wash is wet, using a mix of drier, more concentrated colour. It will become more dilute as it absorbs the water from the first wash.

Too much water in the second wash and it will flood into the first wash and push the pigment grains away, thus creating a backrun. Too little and the pigments will not mix. Both these situations can be remedied if you act quickly: add more pigment into a watery wash, and add more water into dry pigment. But in both instances do this carefully, and by dropping in, or touching in, the water or colour, rather than brushing it on, so as not to disturb the settling pigment grains. The colour may look dark on the palette, especially on a plastic palette, so test it on a piece of paper first before risking it on the painting. Remember that it is the blending of different pigments that looks lovely, not the merging of tinted water.

▷ **A Shift in the Light**
51 x 63 cm (20 x 25 in)
Timing and judgement are essential. To create the delicate darker shades of the skin tones required the gentle brushing in of a drier, darker version of the first wash while it was still damp. The aim is to brush in the colour with one stroke to avoid disturbing the lie of the wash.

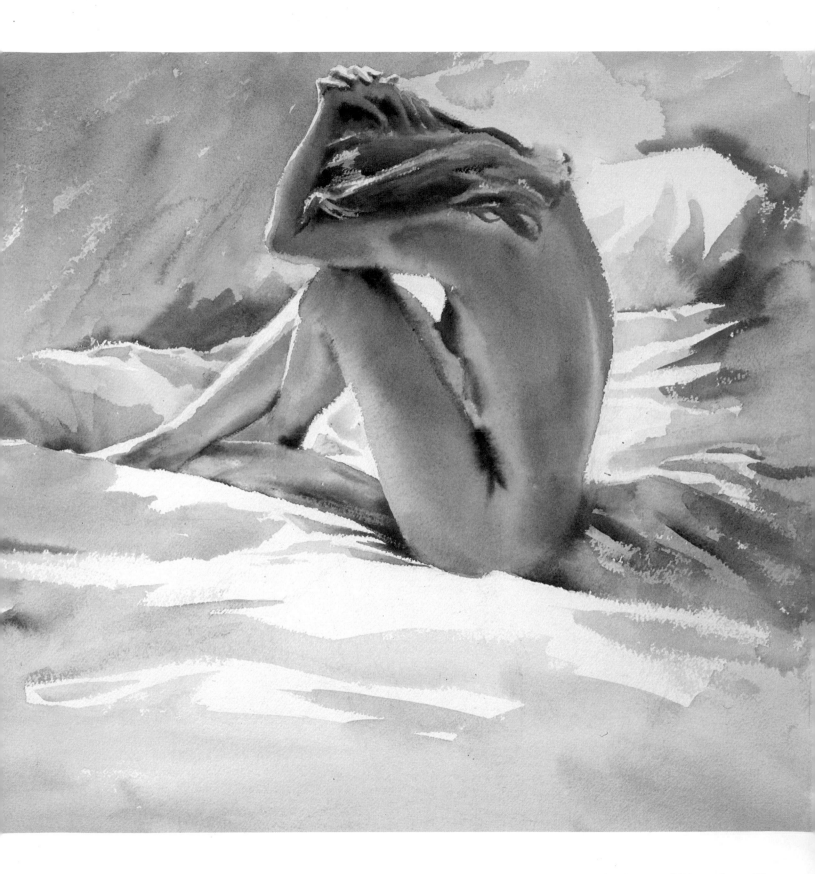

Humidity

On no two days are humidity or temperature exactly the same, so it is impossible to offer an exact science relating to how much pigment to water you need to mix for any given wash or blend. In high humidity, damp, cold or still weather, paintings take longer to dry than on hot and sunny or windy days. Hence the reason the English became masters of watercolour! In the morning and evening, the cooler times of the day, evaporation is slower. Of course it is possible to paint wet-in-wet in all weathers and at any time, but you have to be better prepared, able to work more quickly and possibly on a smaller format on fast-drying days. This does not mean it is more difficult: fast drying and fast decisions often make the best watercolours. The paper you use will also affect drying times and the amount of water you can safely play with in a wash yet still have control. Rough papers tend to dry more slowly and can take more water than smooth papers, while heavy papers dry more slowly and can take more water than light papers. Much of painting is about trial and error. Drying times can only be ascertained when you start painting. Be prepared to practise.

Okavango Dawn
20 x 28 cm (8 x 11 in)
These three watercolours were painted under conditions of different humidity. Look closely at the trees along the banks in each picture. By the spread of the pigment you will be able to tell how damp (or dry) the sky wash was when the trees were touched in wet-in-wet.

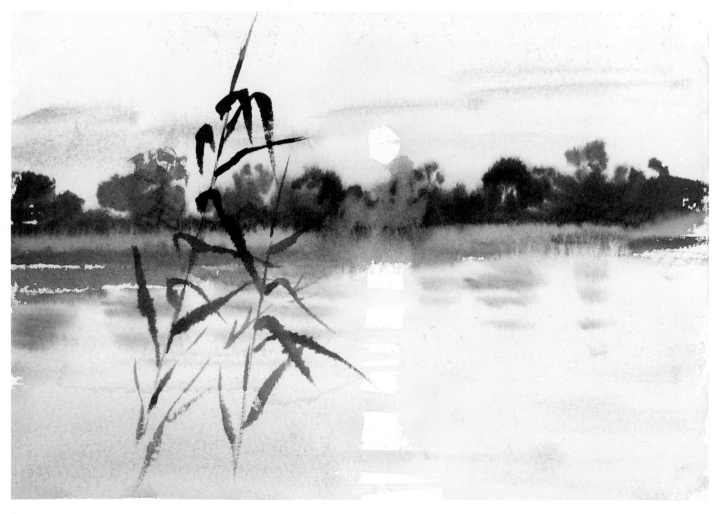

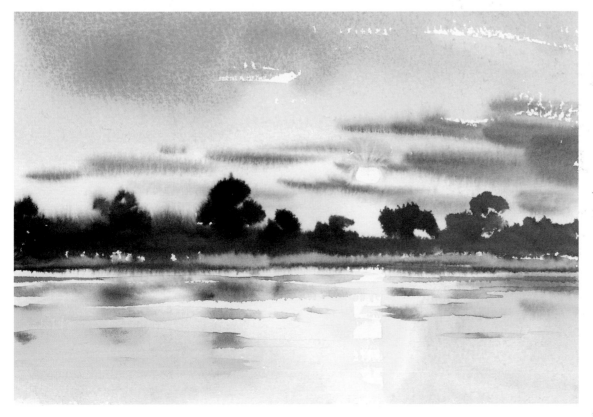

On the Other Bank
20 x 28 cm (8 x 11 in)

**The River
Seldom Waits**
20 x 28 cm (8 x 11 in)

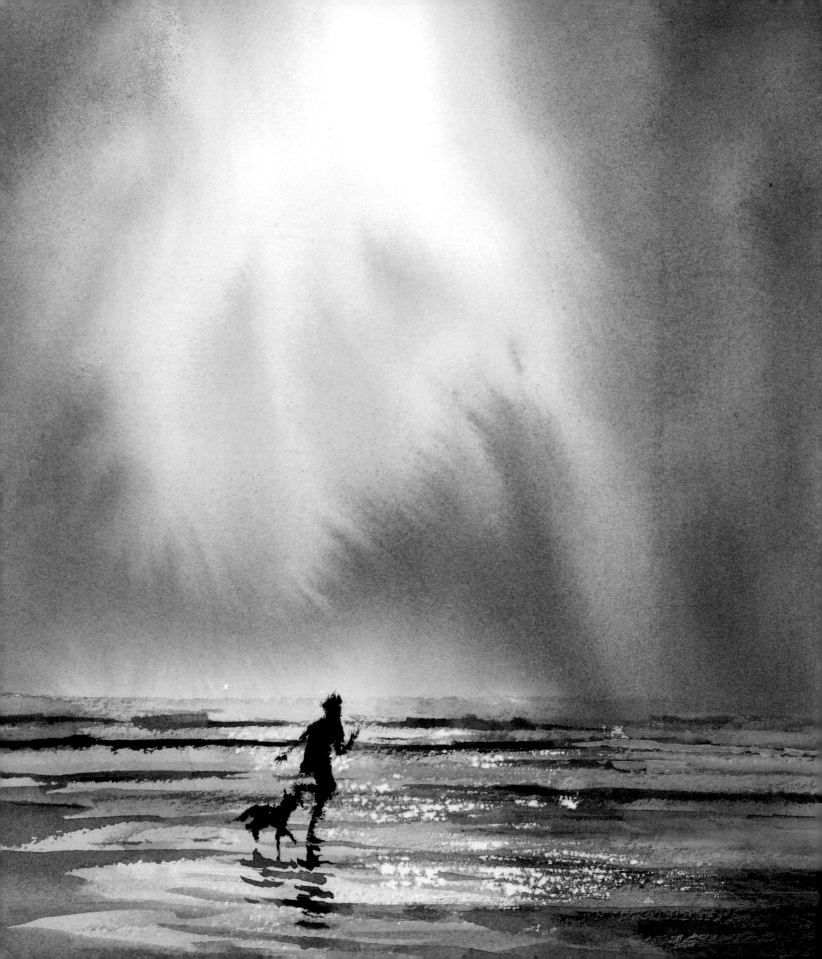

Gravity

◁ **Sean and Yassen Weather the Storm**
33 x 30 cm (13 x 12 in)
The paper is tilted downward to direct the
colours in the sky.

Gravity plays a major part in painting with watercolour. If you work flat the pigment
in a wash can spread evenly and equally outwards; if you work on a slope or at a
vertical angle, the wash will run downwards. If the paper buckles the wet colour
will follow the direction of the dips and will pool in the valleys, so take care how
much water you use.

The nature of water makes it possible to work with watercolour at a near-vertical
angle. The wet pigment flows downwards, so drying occurs faster at the top of a
wash while pigment levels increase or pool at the bottom, thus creating gradual
variations of tone within one wash.

Use gravity to your advantage: tilt the easel or board to direct the flow of
blending paint.

Tilt the paper back and forth to encourage
the mingling of colours.

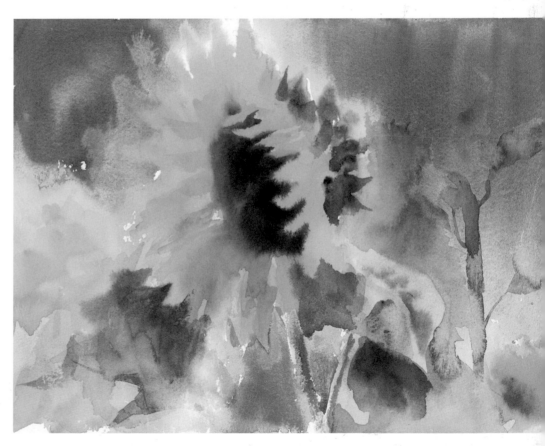

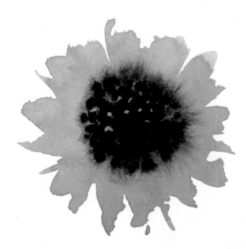

For concentric shapes keep your board flat
to avoid the action of gravity.

Blue Is the Sky
40.5 x 51 cm (16 x 20 in)
The easel was angled more steeply when
painting the sky, but laid almost flat when the
Sepia centre was added to the sunflower, to
avoid misshaping the petals.

Backruns

Backruns are beautiful when you want them and highly annoying when you do not. Understand what creates them and you can use them to your advantage and avoid them happening by mistake. Backruns occur when too much water is added into a previous wash, or excess water pools at the edge of a wash and pushes the pigment back into the drying wash. Water in an added wash will spread out into the first wash, pushing the pigment away with it, devoiding the area of much of the coloured pigment. Beguiling patterns often occur at the edge of the backrun, such as feathered fans or delicate spreading linear fingers, patterns you could never engineer, but less attractive backruns can also result and these are hard to obliterate. If you do not want a backrun to happen, lift out the excess or pooled water with the tip of the brush or the corner of a sheet of kitchen roll. Soak up the water without disturbing the drying paint. Do not pat dry; you will disturb the drying wash. You can control the extent to which a backrun will spread by the amount of water you allow to pool and by tilting the paper.

▽ **In the Footsteps of the Fauves, Collioure**
20 x 28 cm (8 x 11 in)
The dark wash over the silhouetted tower was quite wet and pooled at the base, forming a backrun above the line of the sand. I find backruns attractive, but if they form inadvertently leave them until completely dry and try to disguise them later. Messing with them will only make them more noticeable.

▷ **Explosion in a Pot**
30 x 20 cm (12 x 8 in)
You can create the look of a backrun by throwing salt into a very wet, pigment-rich wash. The salt draws in the pigment, leaving lighter areas around it with a feathery edge.

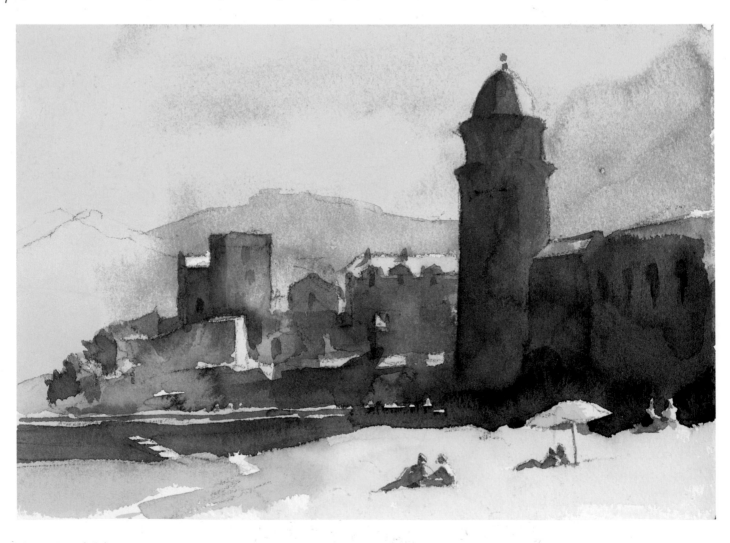

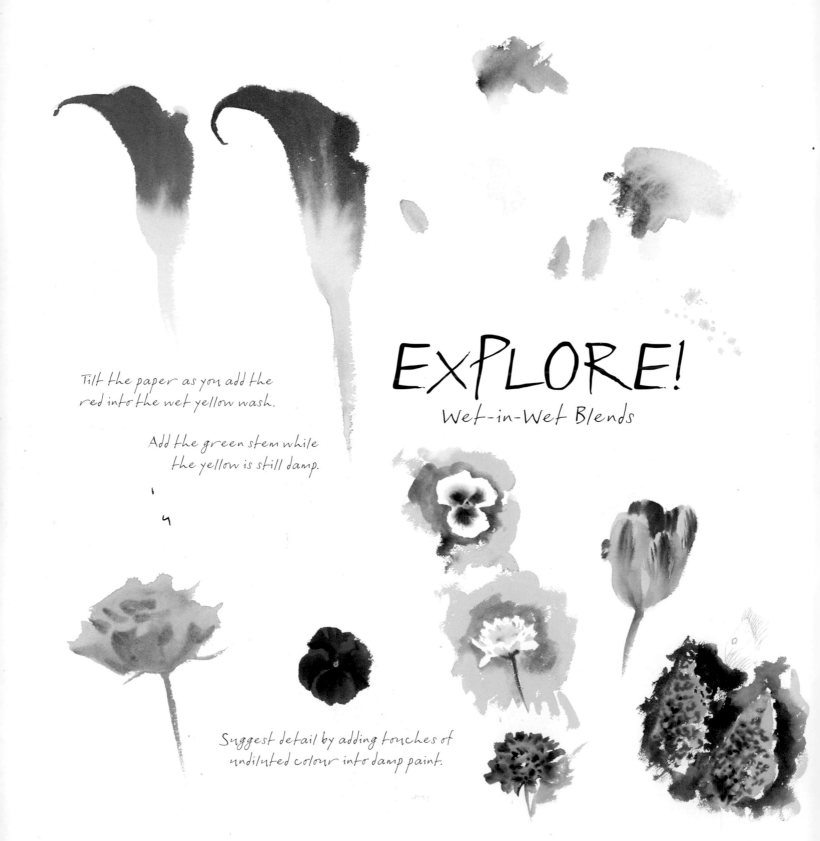

Tilt the paper as you add the
red into the wet yellow wash.

Add the green stem while
the yellow is still damp.

EXPLORE!
Wet-in-Wet Blends

Suggest detail by adding touches of
undiluted colour into damp paint.

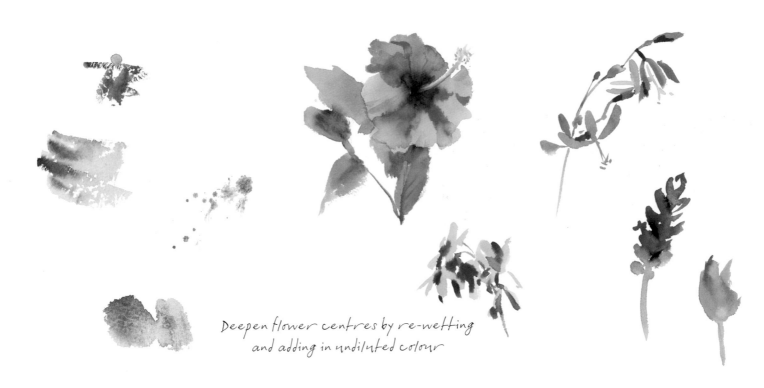

Deepen flower centres by re-wetting and adding in undiluted colour

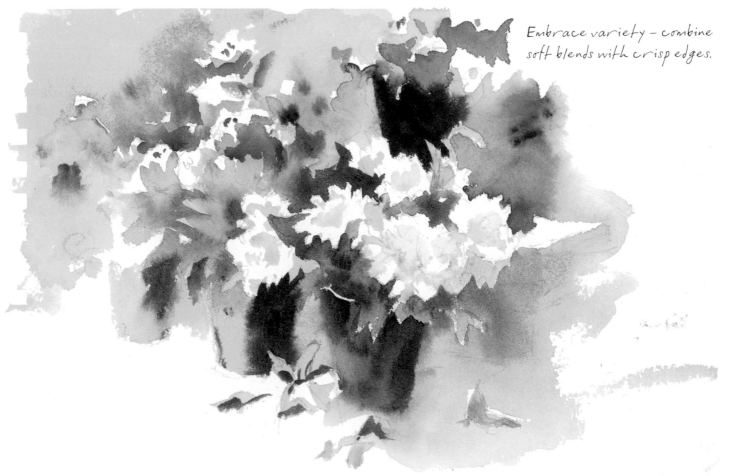

Embrace variety – combine soft blends with crisp edges.

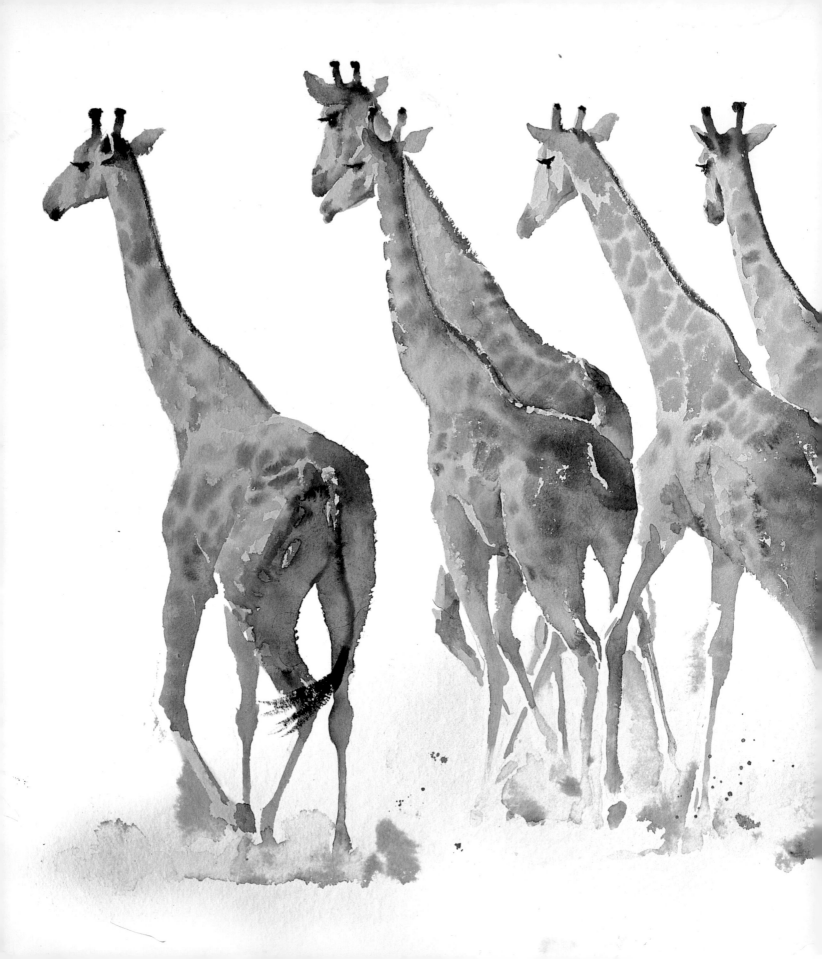

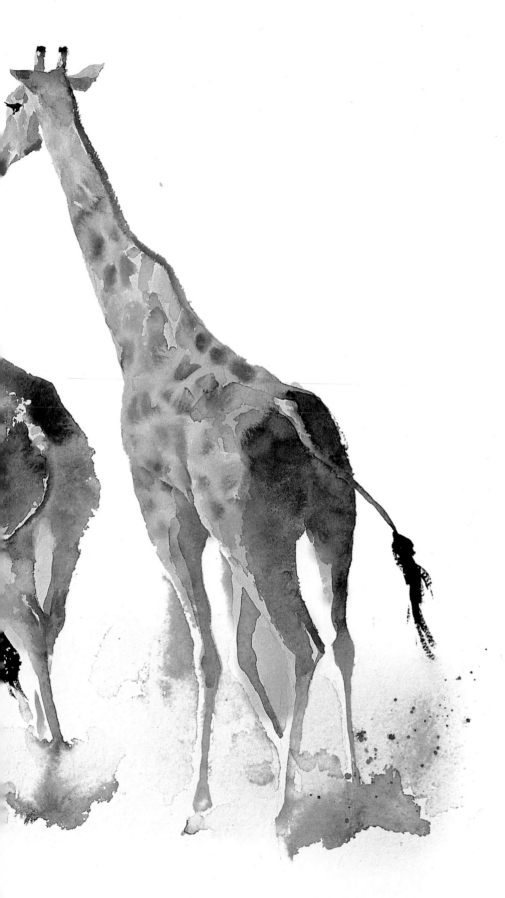

The Way of the Brush

The transparency and radiance of watercolour is apparent even in the palette, but it is only when the pigments are brushed on to paper that they can literally show their colours. The finest instrument for laying watercolour on paper is the sable brush. When you become deeply involved in a painting the brush becomes an extension of the eye, linked to the soul through the dexterity of the hand. Like favourite fountain pens, artists become fond of their brushes, trusting them to deliver the marks they desire.

Taking Flight
56 x 76 cm (22 x 30 in)
The action of the brushstroke enhances the impression of the swift movement of the fleeing giraffe.

The Brushstroke

The aim of good brushwork is to put meaning into the brushmarks and washes and hence into the entire watercolour. Skilful brushstrokes require decent instruments and although sable brushes are more expensive than their synthetic counterparts the difference in cost is worthwhile. Sable brushes are made of natural hair, which has tiny barbs along its strands. These barbs trap water along the length of the hair, and between the hairs, so the brush can hold a lot more pigment than its nylon brother. The taper of natural hair brings even a large brush to a fine point at its tip. This means that a painter can make broad washes and fine lines with just one brush, endowing meaning into each shapely stroke.

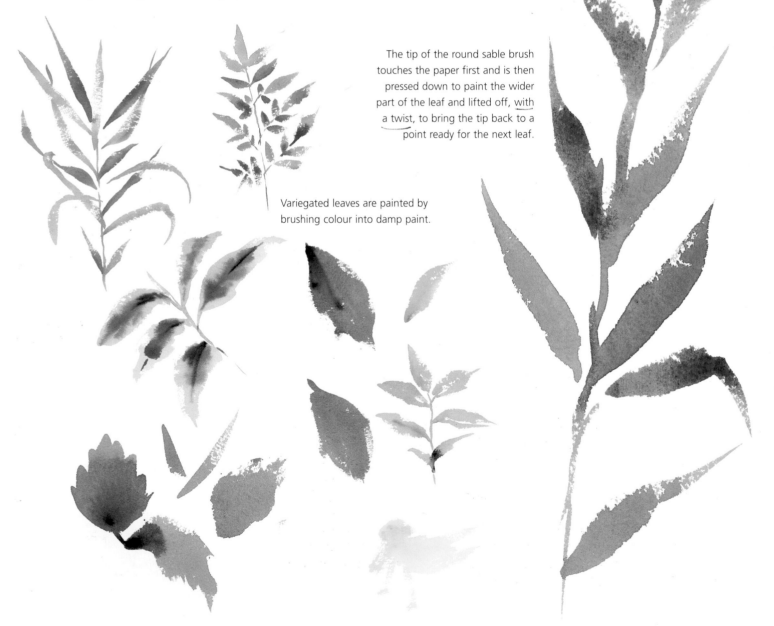

The tip of the round sable brush touches the paper first and is then pressed down to paint the wider part of the leaf and lifted off, with a twist, to bring the tip back to a point ready for the next leaf.

Variegated leaves are painted by brushing colour into damp paint.

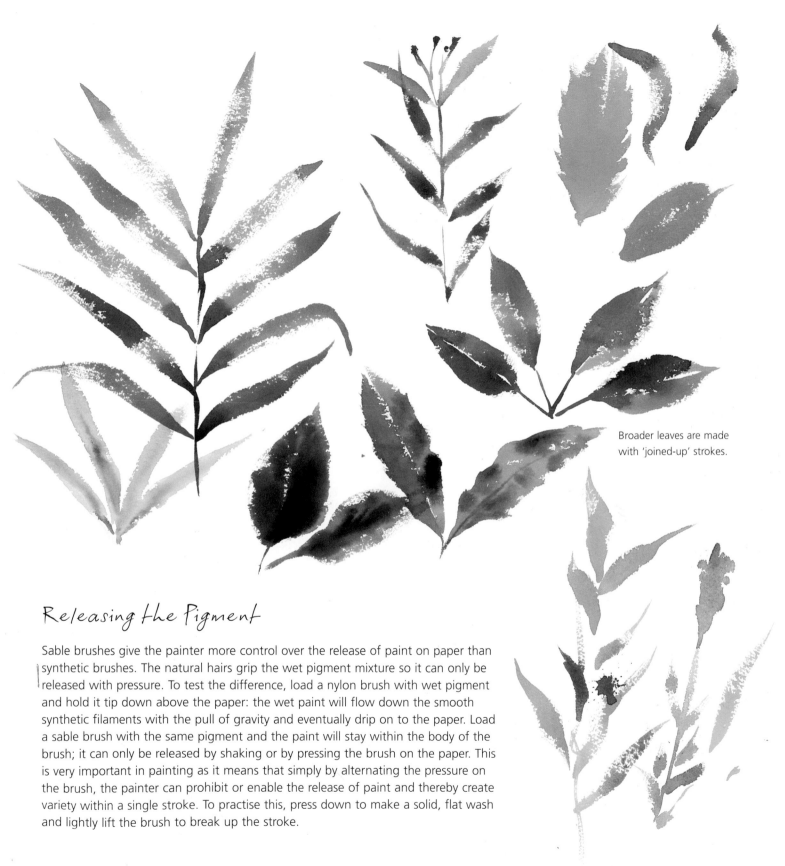

Broader leaves are made with 'joined-up' strokes.

Releasing the Pigment

Sable brushes give the painter more control over the release of paint on paper than synthetic brushes. The natural hairs grip the wet pigment mixture so it can only be released with pressure. To test the difference, load a nylon brush with wet pigment and hold it tip down above the paper: the wet paint will flow down the smooth synthetic filaments with the pull of gravity and eventually drip on to the paper. Load a sable brush with the same pigment and the paint will stay within the body of the brush; it can only be released by shaking or by pressing the brush on the paper. This is very important in painting as it means that simply by alternating the pressure on the brush, the painter can prohibit or enable the release of paint and thereby create variety within a single stroke. To practise this, press down to make a solid, flat wash and lightly lift the brush to break up the stroke.

Shaping the Stroke

The way you make your brushstrokes is crucial to the success of a watercolour. Shape the brush as you load, by twisting and turning it in the colour mixed on the palette to bring its head and tip into shape. Hold the brush lightly between the fingers as you paint, twiddle it between the thumb and forefinger, roll it on to the index finger. As you paint brushstrokes on paper the brush should be rolling around continually in these fingers and changing its angle to the paper, sometimes upright sometimes leaning, both forwards and backwards. Use the tip and body of the brush to make a precise shape with one stroke. Avoid the temptation to make meaningless dabs and repetitive marks.

Practise this dexterity by using one brushload to make many different shapes, alternating between the tip of the brush for a fine, narrow line and pressing down the body of the brush to get the widest mark possible. Create larger shapes with 'joined-up' painted areas rather than outlining and filling in.

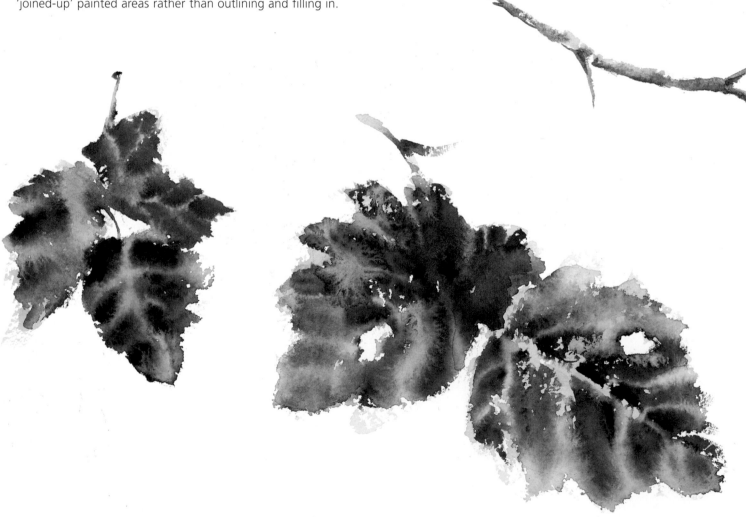

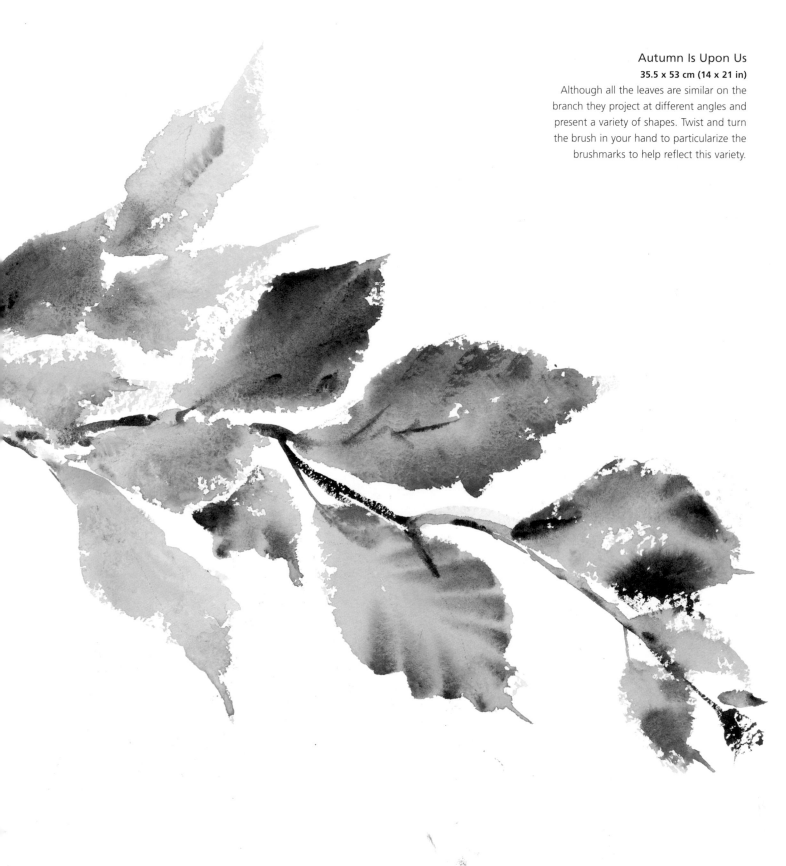

Although all the leaves are similar on the branch they project at different angles and present a variety of shapes. Twist and turn the brush in your hand to particularize the brushmarks to help reflect this variety.

Size Matters

The freshness in a watercolour derives from the least number of brushstrokes needed to make a shape or wash, so use the largest brush you can manage for the size of image chosen. With a round sable, size 12–16, you can create an unblemished wash more easily and in fewer strokes than with a smaller size 6. Mops made of hair or flat brushes are less expensive alternatives to large round sables and allow you to cover large areas quickly and successfully.

Large flat brushes are particularly versatile. They make neat, straight edges and attractive broken backstrokes. They can be used on their sides to make dynamic streaks and carry less water than a round brush so are easier to control. In watercolour, the less times you touch the paper with the brush the better the painting is likely to be. Imagine you are only allowed 50 brushstrokes to make a painting – you would make each brushstroke count!

Incoming
36 x 28 cm (14 x 11 in)
The elephant's characteristics are painted with pertinent marks made by large brushes – a size 12 round sable and a 25mm (1in) flat. The elephant is therefore completed in very few brushstrokes, encapsulating energy within the painting.

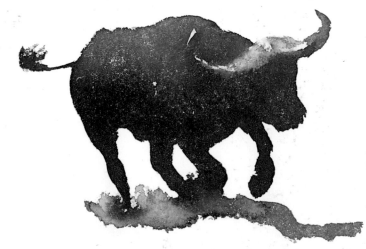

A round sable, size 6 or 8, is the perfect brush for making a sketch this size.

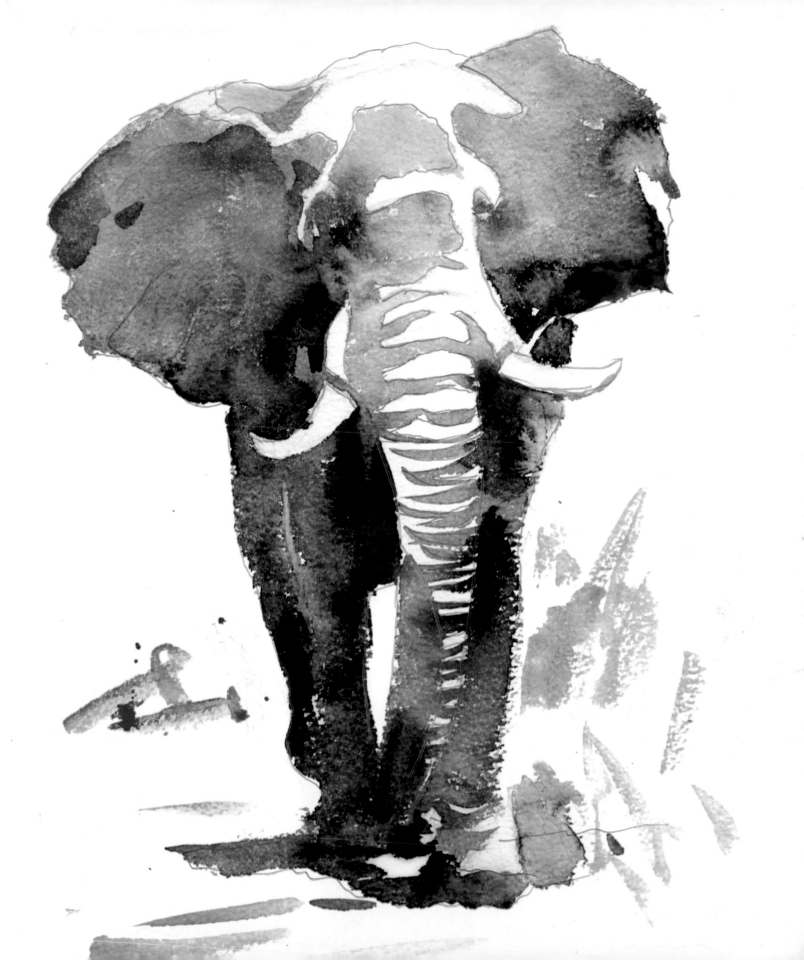

The Edge of the Stroke

Every mark on a painting counts toward the whole. The boundaries of the brushstroke and the borders of the wash are brimming with vitality. Wet washes on smooth papers give clean edges, while drier washes and rough papers create irregularity. Watercolour loves to entertain the eye with this variety. Make strokes that differ on either side by varying the pressure on the head and heel of the brush as you lay the stroke. Working on a rough paper helps this effect as paint catches on the hills and misses the valleys of the textured surface.

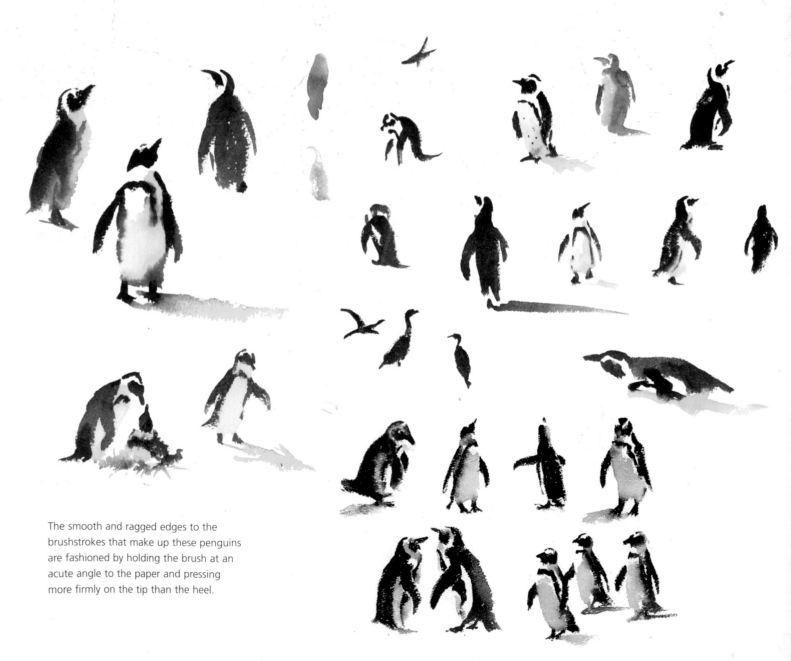

The smooth and ragged edges to the brushstrokes that make up these penguins are fashioned by holding the brush at an acute angle to the paper and pressing more firmly on the tip than the heel.

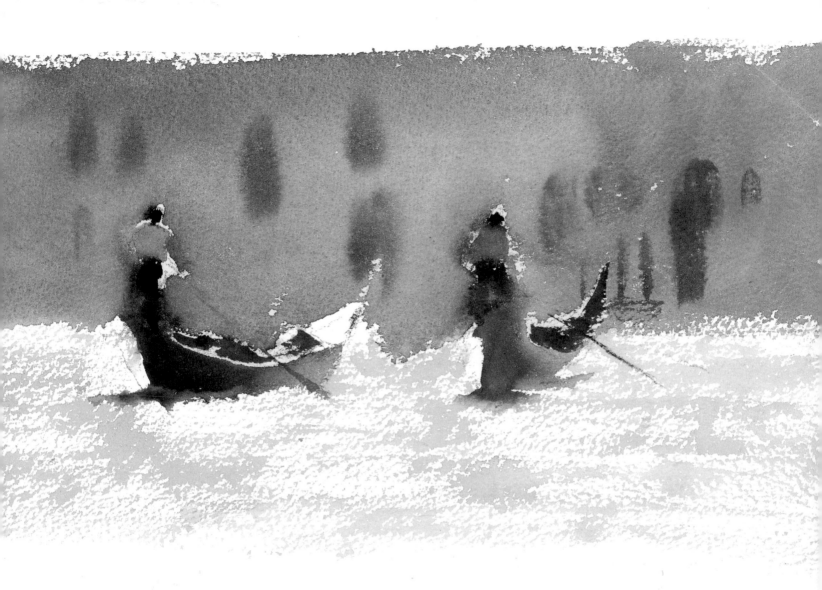

Dry Brushmarks

'Dry brush' is an uneven brushmark that lays a delightful fragmented patina of paint on the surface of the paper. It is beautiful as both a single layer on white paper and as a glaze that allows the undertone to shimmer through. Despite its name, it is not made with either a dry brush or dry paint. It is created by lightly brushing the paper with the side of a thinly loaded brush – the less pressure used, the less paint is released, and the rougher the paper the more fragmented the stroke will appear.

Side by Side
18 x 28 cm (7 x 11 in)
The fragmenting effect of the dry brushstroke is perfect for the sparkle of light on water.

Laying Washes

Laying transparent washes of uniform or gradually changing colour is one of the most thrilling tasks in watercolour painting. Sweep the paint on to the paper in one direction, with as large a brush as possible, and the pigment particles will settle in an immediate, spontaneous, well-balanced distribution, creating a clean, clear transparent wash. Laying a wash requires several adjoining or overlapping brushstrokes. Work from the most concentrated colour to the least intense, even if it means working upside down, and once an area is covered do not go back over it; the colour is laid, leave well alone.

A two-colour blended wash
A large brush aids the blending of colours. Only sweep in one direction for a perfect wash.

A multi-coloured blended wash
Several colours can be blended, one below the other. Prepare them in the palette so they can be applied wet beside wet.

A graduated sky wash
Clear skies can be painted with graduated washes. Start with the most concentrated paint first and gradually dilute.

A variegated wash
A variegated wash is made up of several colours. Paint the palest colours first, then add the darker hues wet-in-wet.

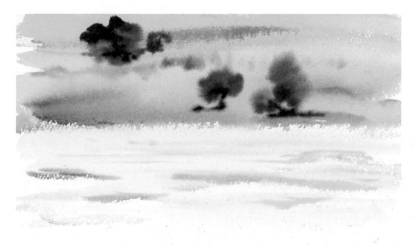

The edge of a wash
The border of a wash is important. The ragged edge at the base of the dune wash makes a more interesting boundary with the foreground than an even line.

Leave Well Alone

It feels good to brush paint on paper and it is hard to resist adding more brushstrokes, but repeatedly painting an area will not improve it. If you paint by dragging your brush back and forth, over and over the same spot, you will prevent the natural settlement of the pigment and lose the chance of optimum clarity.

Watercolour is so tolerant that it will often let you get away with this, but beware if you then brush yet more diluted colour over a drying wash: you will disturb the grains, pushing the pigment into clumps, and thus the dreaded mud is born!

Your job is done once the brushstroke is made. Leave the rest up to the watercolour and it will look fresh and shimmering.

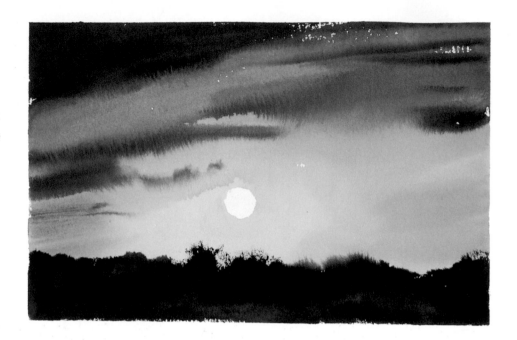

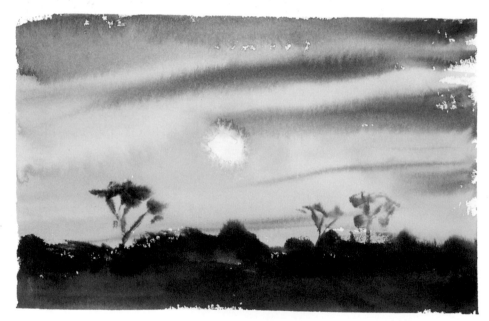

Take Two (African Sunsets)
12.5 x 18 cm (5 x 7 in)
Brushing in the sky for a sunset takes only a few seconds and the temptation is to keep on brushing, especially as it takes a while to dry. Have a spare sketchpad ready so you can start another painting rather than wreck the freshness of the first.

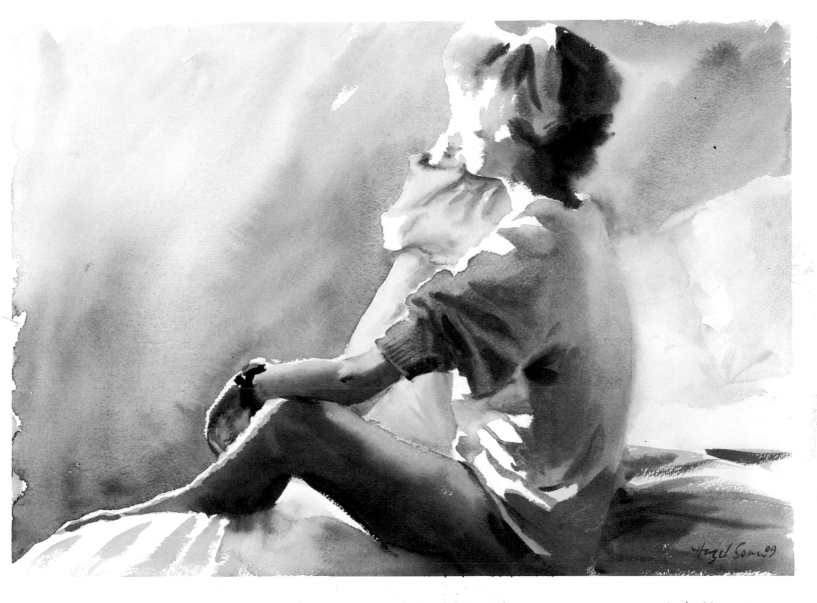

In the Moment
46 x 66 cm (18 x 26 in)
Some colours have a tendency to granulate on
the paper, giving a natural texture to a wash. If
left alone to settle a delightful patina emerges.
Here you can see the granulation of Raw
Umber across the background, in the hair,
and on the jersey.

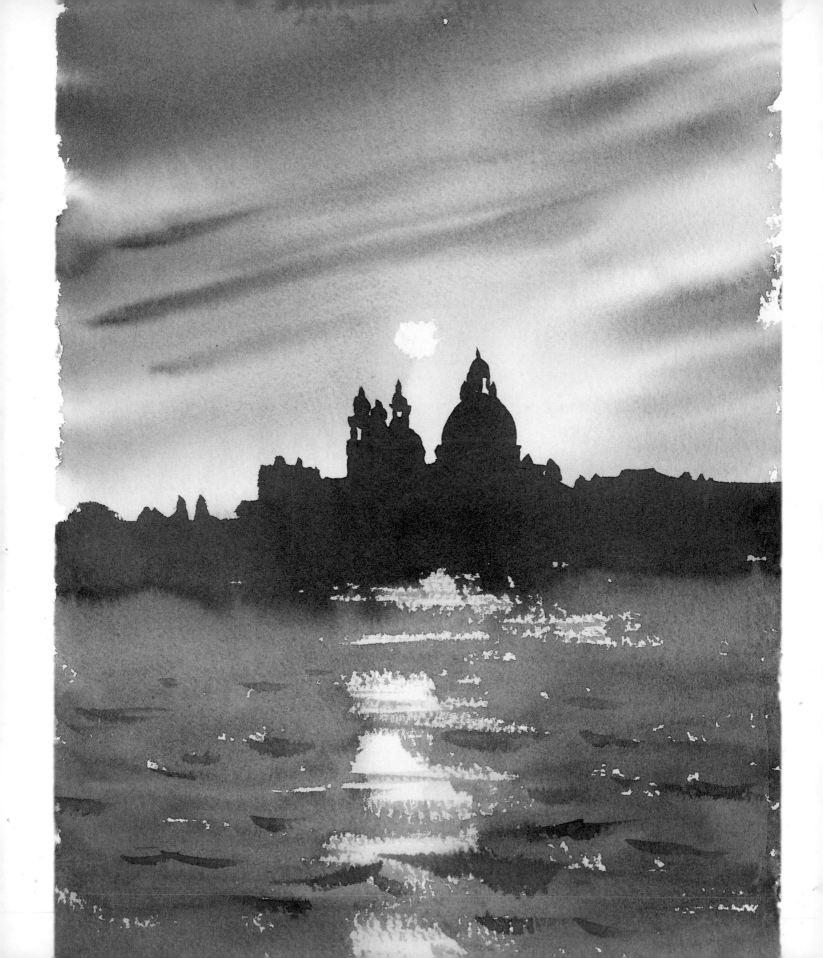

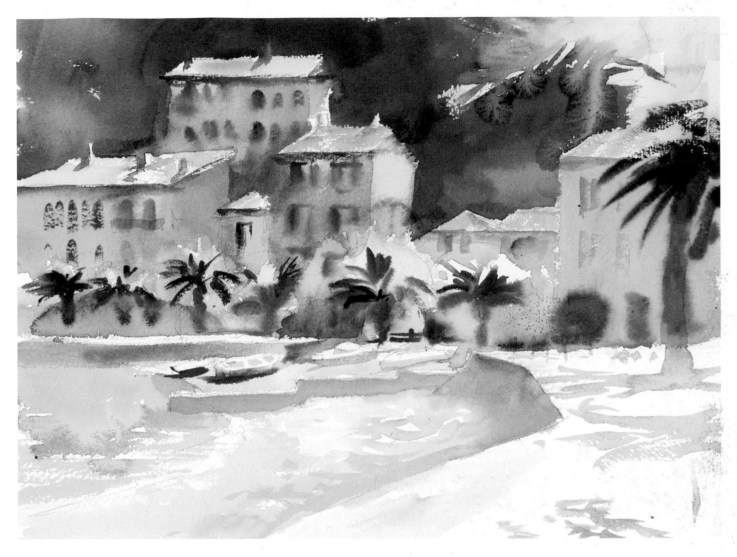

Wetting Paper

The Glow of Aureolin in the Morning
35.5 x 46 cm (14 x 18 in)
In this preliminary sketch the background area has been wetted prior to laying the variegated wash to encourage a gentle mingling of the dark colours and to avoid 'seams' when reloading the brush.

◁ Venetian Dusk, Santa Maria della Salute
25 x 20 cm (10 x 8 in)
The paper was wetted before laying a pale yellow sky wash to ensure it stayed damp long enough for the introduction of the dark streaks for the clouds.

For a large wash it definitely helps to wet the paper before you start as this greatly assists the flow of the paint and encourages the merging of brushstrokes. When you dampen the paper be aware how much water you are laying, knowing that the amount of water on the paper will further dilute the paint.

Wetting the paper before applying an individual brushstroke ensures a soft gentle edge to a stroke. If you want the edge of a stroke to disappear altogether, wet the paper *beyond* where the applied paint can flow (this may mean wetting to a fuller extent than you expect until you get used to watching paint on the move). As paint creeps towards the edge of the wetted area use gravity to tilt it back to the source. Do not be tempted to increase the wetted area once the pigment is added – the newly added water will move back towards the advancing pigment and disrupt the even flow.

The First Wash Is the Freshest

The most appealing, vibrant passages of watercolour are those that are direct and immediate. Aim to achieve the most you can as soon as you can and with the minimum of means. Take your time, do not rush, but do not vacillate either. Since a single layer of watercolour with a subtle change of hue or tone within its span is a source of beguiling radiance, why not put all your energy into making that one stroke, that one wash, work. Spend your time in the palette mixing to the right consistency, hue and tone, then you will be ready to put full concentration into laying the paint. The most direct way to achieve this is to work wet-in-wet, adding darker tone or change of hue into the freshly laid brushstroke or wash so the blend is achieved within the single layer of paint.

Braids
40.5 x 30 cm (16 x 12 in)
By working wet-in-wet this painting of a Himba girl was made primarily with a single layer of dilute Light Red into which subtle and dramatic changes of hue and tone were added – as a result, freshness prevails.

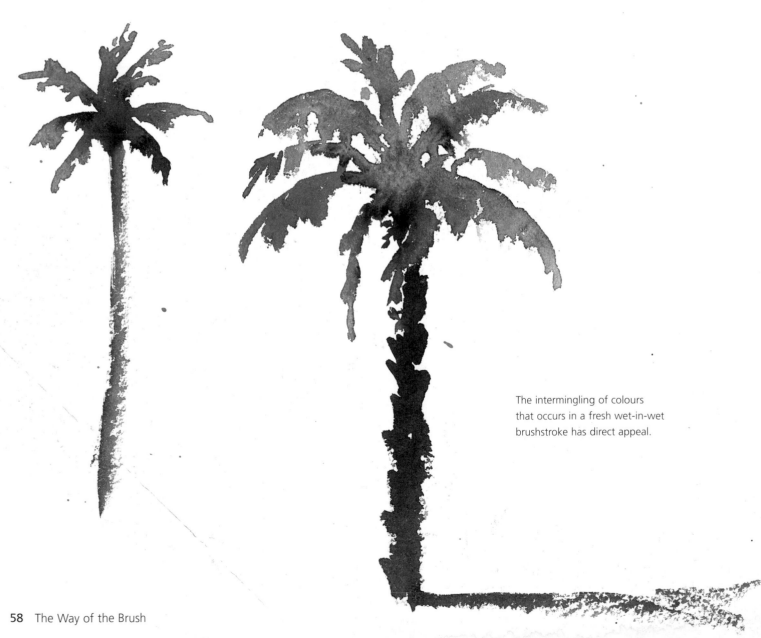

The intermingling of colours that occurs in a fresh wet-in-wet brushstroke has direct appeal.

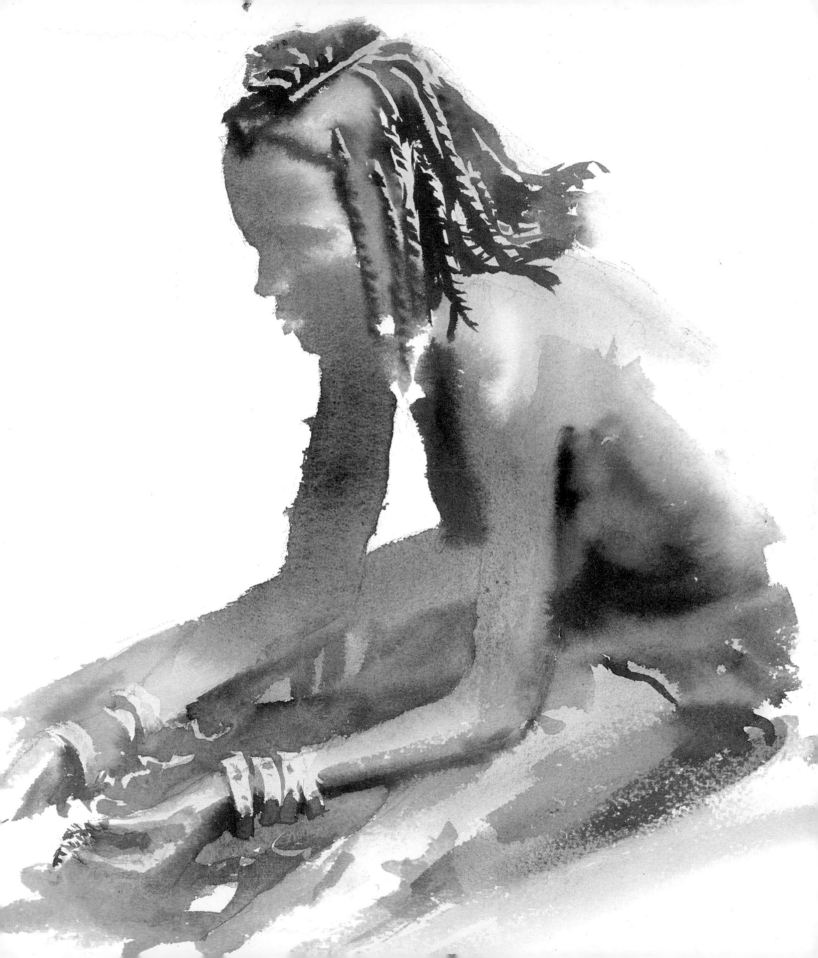

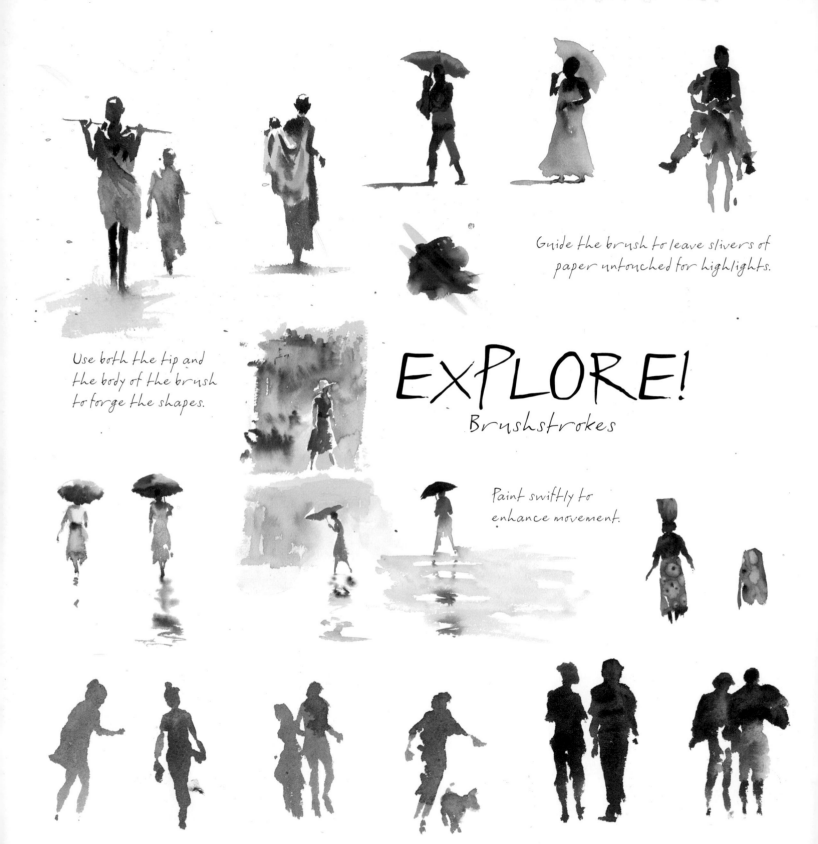

Guide the brush to leave slivers of
paper untouched for highlights.

Use both the tip and
the body of the brush
to forge the shapes.

EXPLORE!
Brushstrokes

Paint swiftly to
enhance movement.

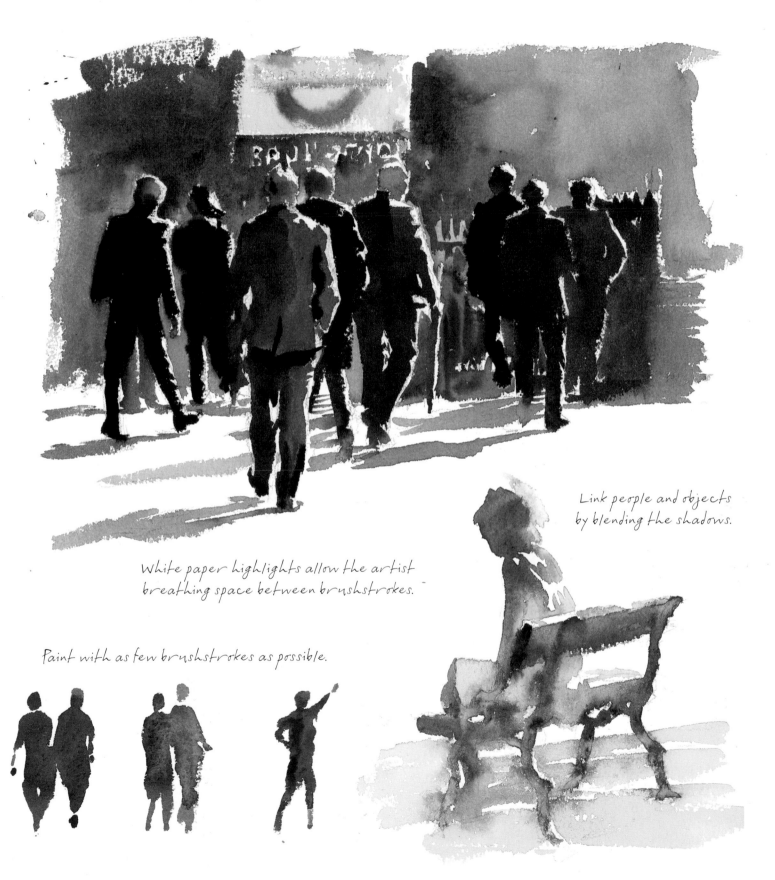

Link people and objects
by blending the shadows.

White paper highlights allow the artist
breathing space between brushstrokes.

Paint with as few brushstrokes as possible.

4

Playing the Right Note

Success in figurative painting is inextricably linked to tonal value. The hue of a colour may lead the heart, but the mind is persuaded by tone. Tone is the language of form, space and depth. Balance of light and shade creates the illusion that three dimensions exist within the two-dimensional expanse of paper, drawing the viewer into the painter's world. The hues of watercolour pigments are such beguiling sirens that they often distract the unwary painter from the primacy of tone and many a lovely passage of paint has to be sacrificed when tone is not honoured from the start.

The Pope's Door, Pienza
40.5 x 51 cm (16 x 20 in)
Three-dimensional form is conveyed by the various different tones that play across the angled surfaces.

Tonal Values

Tone, or tonal value, represents the paleness or darkness of a colour and describes the relative amount of light an object is receiving. A light tone suggests something is lit, while a dark tone suggests it is in shadow. In figurative painting an interesting composition is usually made up of a satisfying, or convincing, balance of light, dark and mid tones.

A colour is made up of both hue and tone. The actual colour of a pigment is called its hue; the shade from pale to dark is called its tone. Confusion often arises when a dark hue is lit, or when a light hue is in shadow: instead of assessing the tone of the colour the hue is seen to dominate, especially if it is strong, and the tonal values of the painting become muddled.

A quick tonal sketch simplified the dinghy on the water into three main tones: the light and dark tones on either side of the hull and the mid tone of the water.

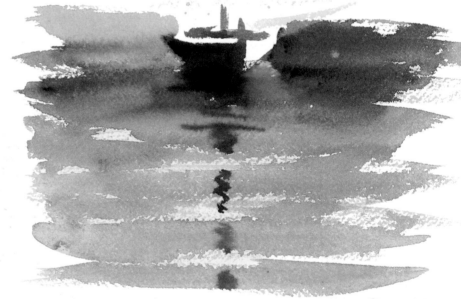

In the coloured sketch the tonal balance is maintained, but the added hues introduce an increased range.

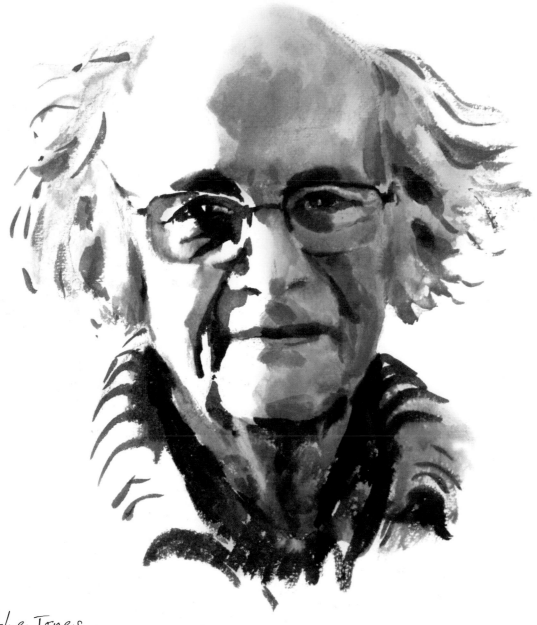

Seeing the Tones

When you observe your subject look for the range of tones from light to dark. In painting tone is always relative, rather than absolute, so you will be thinking in terms of 'lighter than' or 'darker than'. Be aware that the lightest tone may not be white, nor the darkest tone black. Determine the strength of each tone in relation to another and in relation to the whole.

The easiest way to assess tone is to screw up your eyes until the hues of the colours diminish and the lights and shades prevail. This visual reduction is the key to the information you need for a watercolour – the highlights and darks remain visible, but areas of similar tone unite and non-essential details vanish or blur. Try to simplify the subject into three main tonal values – the highlights, the darks and the mid tones.

My Father
46 x 30 cm (18 x 12 in)
Tone is clearly visible in a black-and-white world. Painting a face in monochrome allows the eye to concentrate on the tones without the distraction of colour.

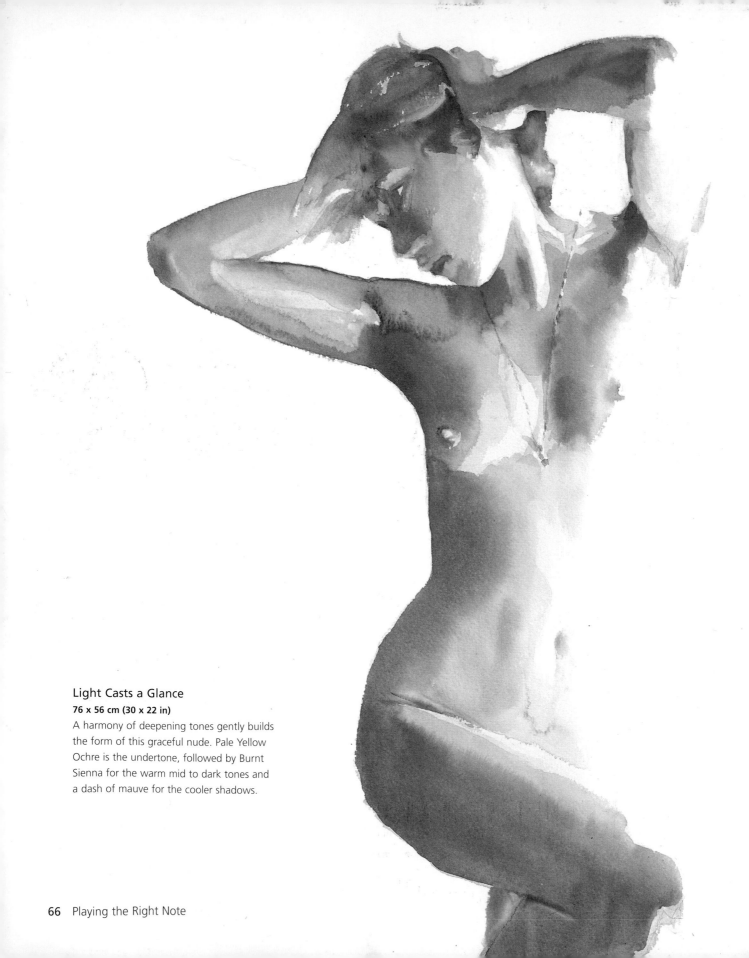

Light Casts a Glance
76 x 56 cm (30 x 22 in)
A harmony of deepening tones gently builds
the form of this graceful nude. Pale Yellow
Ochre is the undertone, followed by Burnt
Sienna for the warm mid to dark tones and
a dash of mauve for the cooler shadows.

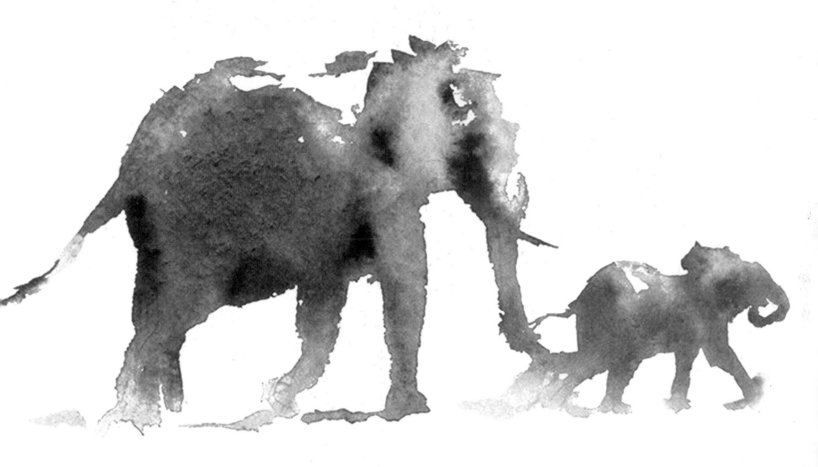

Building Tone

The ease of dilution with water and the transparent nature of watercolour pigments makes it easy to build up a range of tones from light to dark both in the palette and directly on the paper.

Early pale undertones can be used to establish the layout of your composition, leaving areas of untouched white paper for the highlights. The mid tones are built on top, overlapping to make more, and the dark tones are struck last. The beauty of a transparent medium is that you can work in any order, and with a number of layers, to create the tonal structure of the painting. This means you can adapt the method to the circumstances. For example, if you were working outside on a sunny day the positions of the shadows could be recorded in transparent blues or violets right at the start, or laid as glazes at the end, or brushed directly in a single layer, wet-in-wet, merging with the objects that cast them.

Rising Dust (detail)
10 x 15 cm (4 x 6 in)
The augmentation of the innate tones of yellow, red and blue (light, medium and dark), applied in sequence, constructs the bulky forms of the elephants, while the blending of the three hues on the paper makes the lively grey.

Surrender Detail

Caprivi Kraals
18 x 30 cm (7 x 12 in)

There were many more fence posts, roof supports, bushes and other superfluous details in this scene, but the main lights and shades are all that were needed to evoke this fragment of African living.

The details that become indistinguishable when you half close your eyes to judge tonal values are mostly those that are unnecessary in the watercolour. There is no need to tell the viewer everything; we know how the world looks, but we have never seen your painting before. Your vision, your interpretation, is the appeal; the way you use watercolour is the attraction. Decide your focus, concentrate your energy into that and let the rest of the painting serve as support. Sacrifice irrelevant detail to the overall tonal balance.

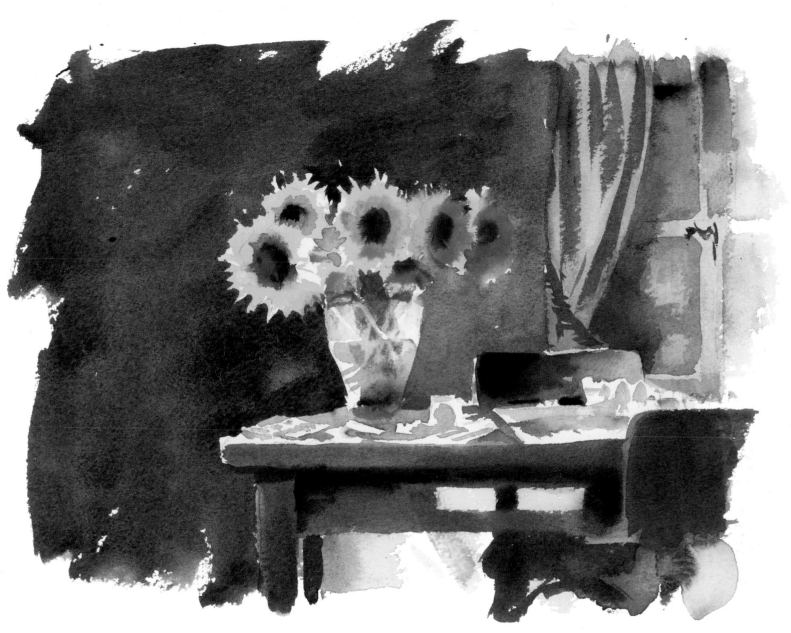

Lost and Found

Simplifying the tonal values means joining up areas of similar tone. This is especially true when painting shadows and darks, and this method often helps create a marvellous sense of mystery.

Allow areas in shadow to dissolve Into one another, so that distinction is blurred. Any shape, line or form in the darkness that needs emphasis can be suggested wet-in-wet with more concentrated pigment. This will suggest detail exists without altering the overall tone.

Highlights by contrast benefit from crisp edges and, just as details dissolve in the darks, so extreme light also bleaches out detail. Highlights may also be linked in a shape that includes several items.

Van Gogh's Sunflowers, Cézanne's Table, Uzès
20 x 28 cm (8 x 11 in)
The shape of the sunflower blooms facing the light have a crisp 'found' edge against the dark background, whereas the flowers facing away from the light are soft, 'lost' in the background wash.

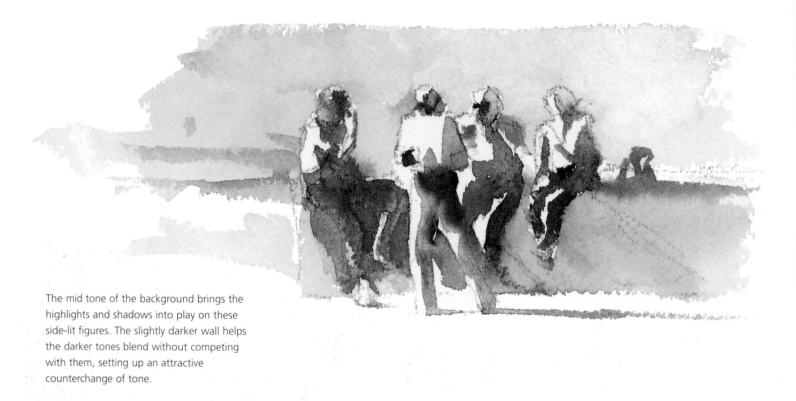

The mid tone of the background brings the highlights and shadows into play on these side-lit figures. The slightly darker wall helps the darker tones blend without competing with them, setting up an attractive counterchange of tone.

Counterchange

Variety, both subtle and blatant, is an important ingredient in watercolour painting. The relative contrast of light and dark tones is the lifeblood of a watercolour. If your painting looks dull the first point to check is that there is a sufficiently interesting tonal range throughout the painting. Confirm that darker and lighter tones alternate across the painted surface and that within the washes and brushstrokes there is some tonal variation.

Tonal counterchange not only appeals to the eye but creates depth in the painting. By placing a light-toned feature in front of a darker one, the painter convinces the viewer that one object lies in front of the other and thus alludes to space. Strong tonal contrast and a wide range of tones increase the illusion of space and strengthen the impression of three-dimensional form.

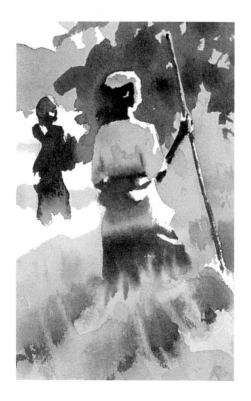

Here the counterchange is against an alternating background tone. The further figure is dark against a light background, while the nearer figure is light in tone against a background of darker trees.

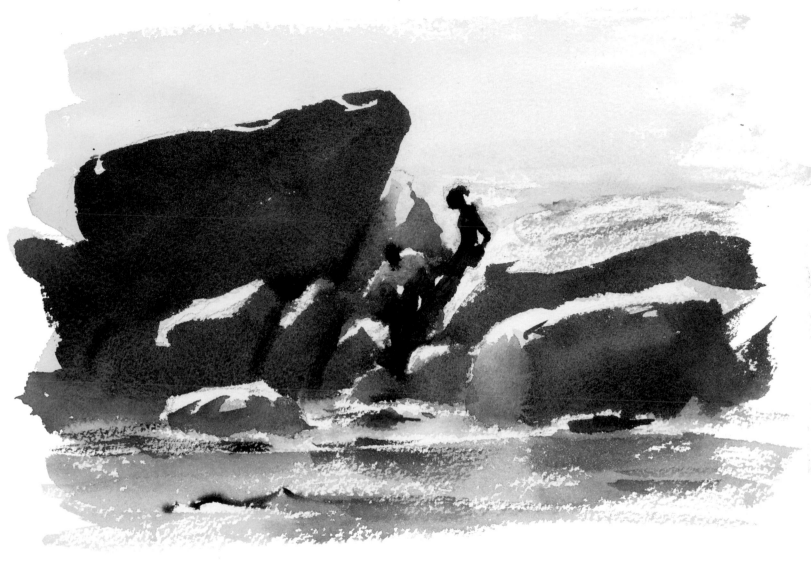

Be Bold

The appearance of visual spontaneity in a watercolour arises from the most immediate application of brushstrokes and washes. It is therefore to your advantage to lay colour in the right tone at first application or as early as possible. Attempting to darken a tone with layer upon layer of similarly weak colour will result in dullness rather than strength. Do not be afraid of the dark, but aim to be bold. It is heartbreaking to have painted some lovely watercolour washes only to find they are too weak and must be reworked to make structural sense in the painting. Once overpainted these washes lose their immediate appeal and the ghastly sense of regret starts to seep in. This saps confidence and the net result is a feeling of failure. Being bold may not always work but using strong colours and making brave brushstrokes has the emotional result of increasing confidence.

Clambering
20 x 25 cm (8 x 10 in)
Being bold keeps the painting fresh and alive. The dark-toned rocks were painted with one 'joined up' wash of a strong dark mix of Burnt Umber and Ultramarine Blue.

Simplify an angular form to find the generalized tone of each facet – light, mid, dark.

On a rounded form change the tone gradually from light to dark.

EXPLORE!
Form and Space

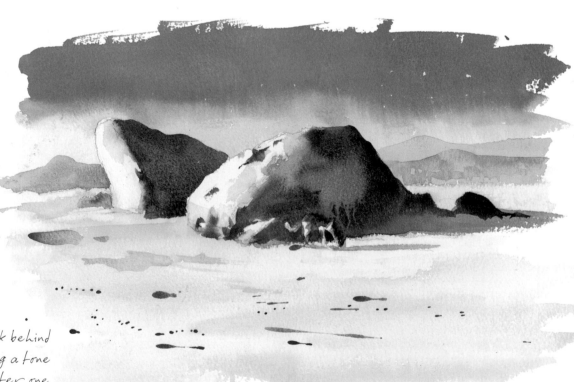

Suggest depth, one rock behind the other, by darkening a tone behind a lighter one.

Observe relative tone: the
rocks appear lighter against
a mid-toned blue sky, but darker
against a white sky.

Practise 'lost and found' – merge the shaded
areas, and highlight the lit areas.

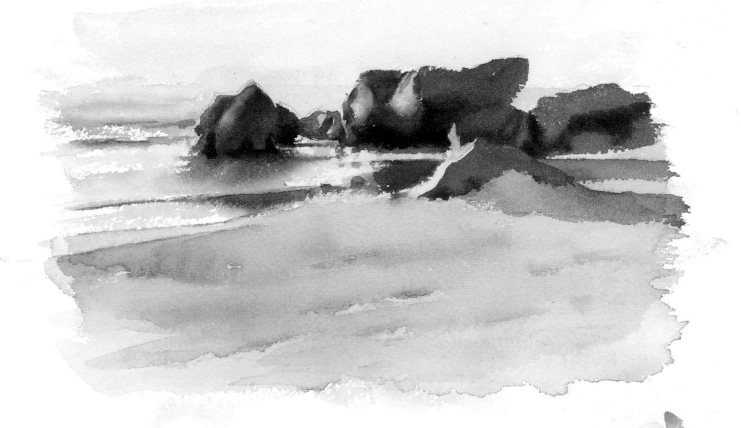

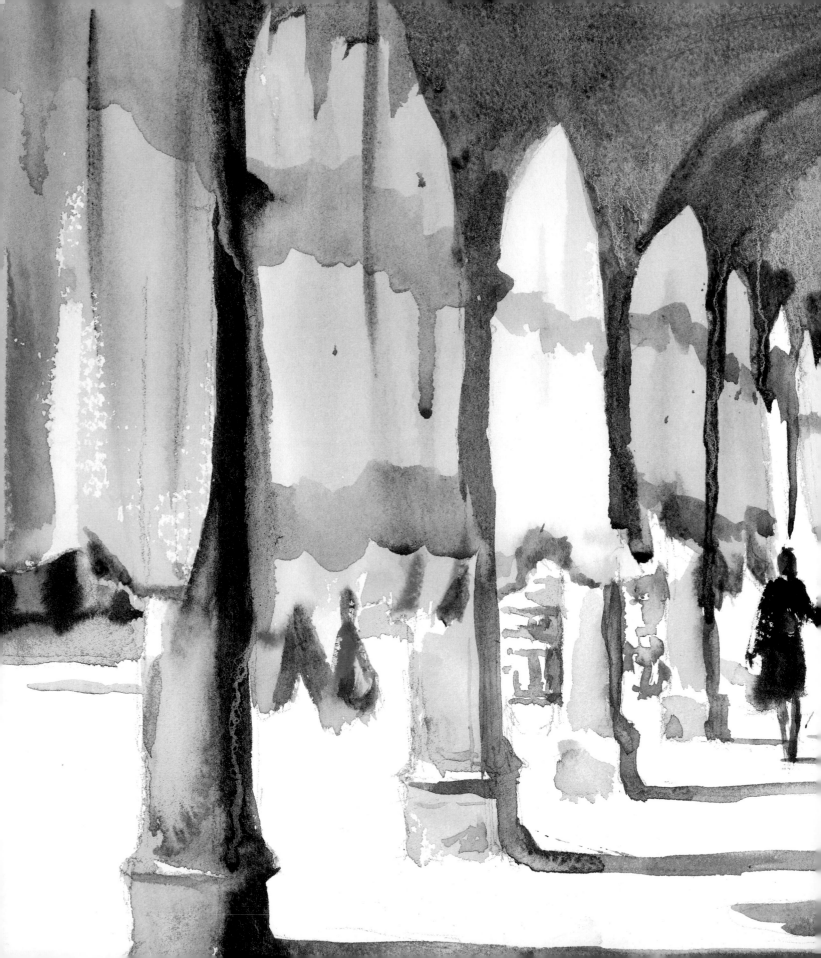

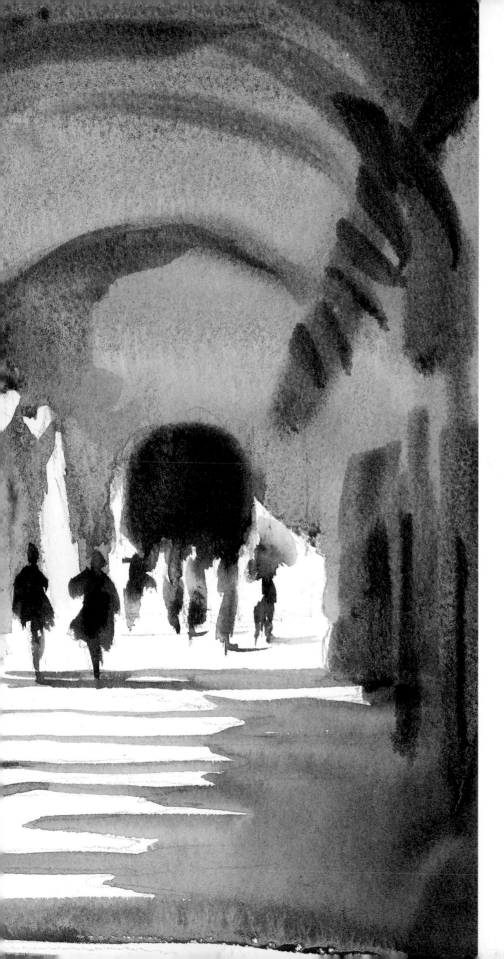

5 Painting the Light

Watercolour is renowned for its ability to portray light in a painting. Watercolour paper is a creamy off-white, and yet such is the luminosity of the virgin paper that the segments left untouched between brushstrokes and within washes render the presence of light perfectly. Since light is represented by untouched white paper it follows that it is impossible to paint light. Only by painting the shade surrounding the light can light be made visible in a watercolour.

Venetian Shades, St Mark's Square
30 x 40.5 cm (12 x 16 in)
The white paper and transparent hues of watercolour are excellent at capturing the effects of sunlight.

The highlights on the tops of hats and bent backs are untouched white paper, deliberate gaps left in the Viridian wash.

Reserving White Paper

The white paper provides the brightest highlights in watercolour, so it is necessary to safeguard those areas from brushstrokes or washes. In a simple sketch or composition this is a straightforward matter of leaving spaces between the brushstrokes or taking pressure off the brush, but in a more complex design it requires planning. A pencil drawing makes a good guide for the brush, to tell it where it can and cannot go. The marks should be fluid and light and can be made with anything from a soft 2B pencil to dark graphite. Aim to rub out as little as possible to avoid disturbing the pristine surface of the paper and use a putty rubber when the need arises. It is quite all right to leave the pencil marks showing in a watercolour and once covered with paint they cannot be erased.

Dusky Canal
15 x 35.5 cm (6 x 14 in)
Because of the many highlights in this canal scene, a preliminary pencil sketch was made to mark where the white paper should be left untouched.

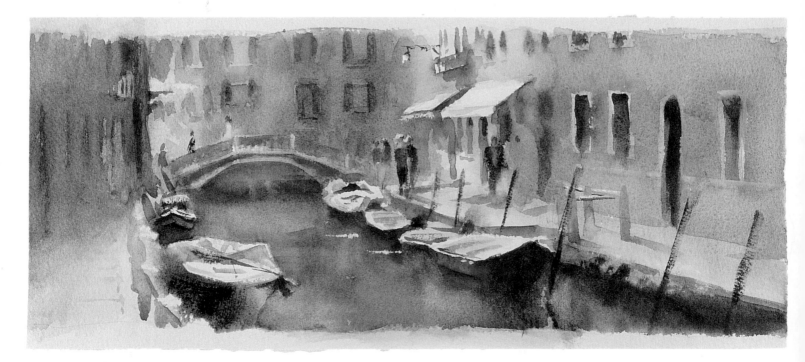

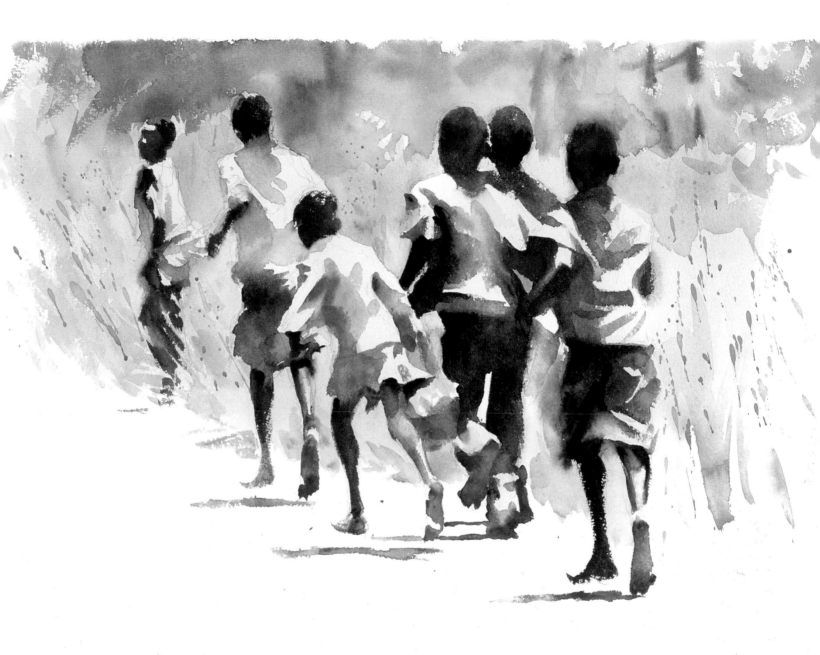

Lozenges of Light

The freshest watercolours are those in which the shapes of the highlights are made by the gaps between the smooth and rough edges of the surrounding brushstrokes. Try not to follow your pencil lines too carefully – the shapes of light do not have to be exact. Ambiguity and variety are great assets in a watercolour and often it is the quirky shapes of light that lend the most shimmer to a painting.

Running in Bare Feet
38 x 56 cm (15 x 22 in)
The shapes of the white-paper highlights on the clothing are fairly specific and benefit from the immediacy of the brushstrokes. They are indicative of the movement in the fabrics as the children run.

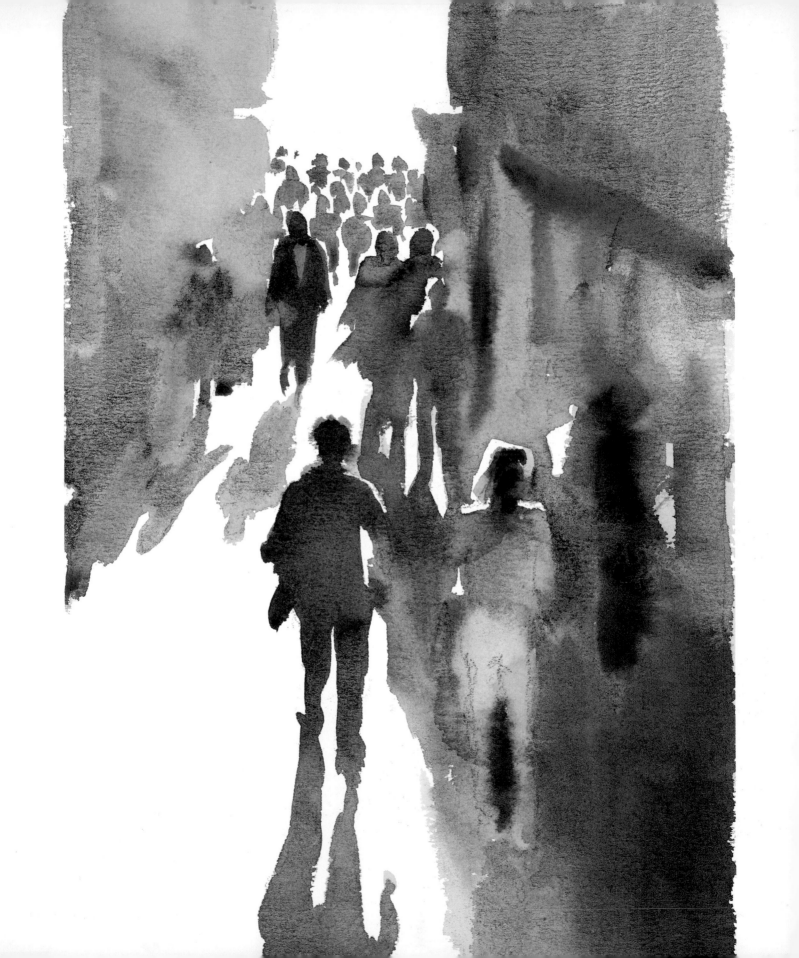

Direction of the Light

It is important to be consistent with the direction of the light. Painting outside will make you more aware of this as the Earth's movement changes the direction of the light and the swift progress of shadows can be easily followed. Photographs capture a moment in time, so working from a single image will give you a consistent light source, but if you are piecing together a composition from several sketches or photos make sure you maintain harmony in the light. Under normal daylight, the topsides of objects will catch the light. In the morning and afternoon the light will come from a lower angle and light the sides as well. Always note the direction of the light – the white paper highlights must be on the lit side of any object, and if you unwittingly leave slivers of white paper on the shaded or undersides of your subject the painting will not make sense.

Multiple Highlights

In a complex painting with many highlights a latex liquid called masking fluid is often used to preserve small areas of white paper. It has a tendency to make globular-shaped highlights unless you apply it with careful attention, but its use means you can freely paint washes across the paper without fear and so gives confidence and freedom of movement to the brushstrokes. Use only light-coloured or colourless masking fluid as anything darker will make it harder to establish the other tones in relation to the highlights you are protecting.

◁ **Street Art**
30 x 25 cm (12 x 10 in)
Looking towards the light source is termed 'contre jour'. This backlit direction presents interesting patterns of light and shadows to the artist.

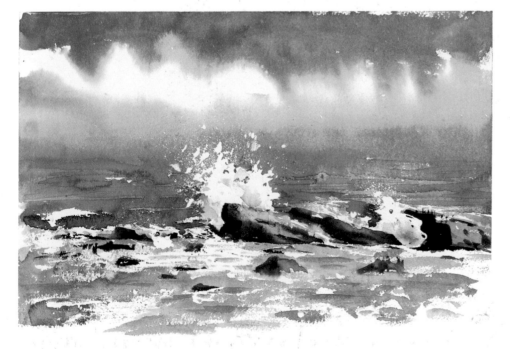

The Fist of the Ocean, Cape of Good Hope
25 x 35.5 cm (10 x 14 in)
The fine spray thrown up by waves dashed against the rocks was reserved with masking fluid spattered from the bristles of a toothbrush. At this unfinished stage it is rubbed off before the final details of the painting are completed.

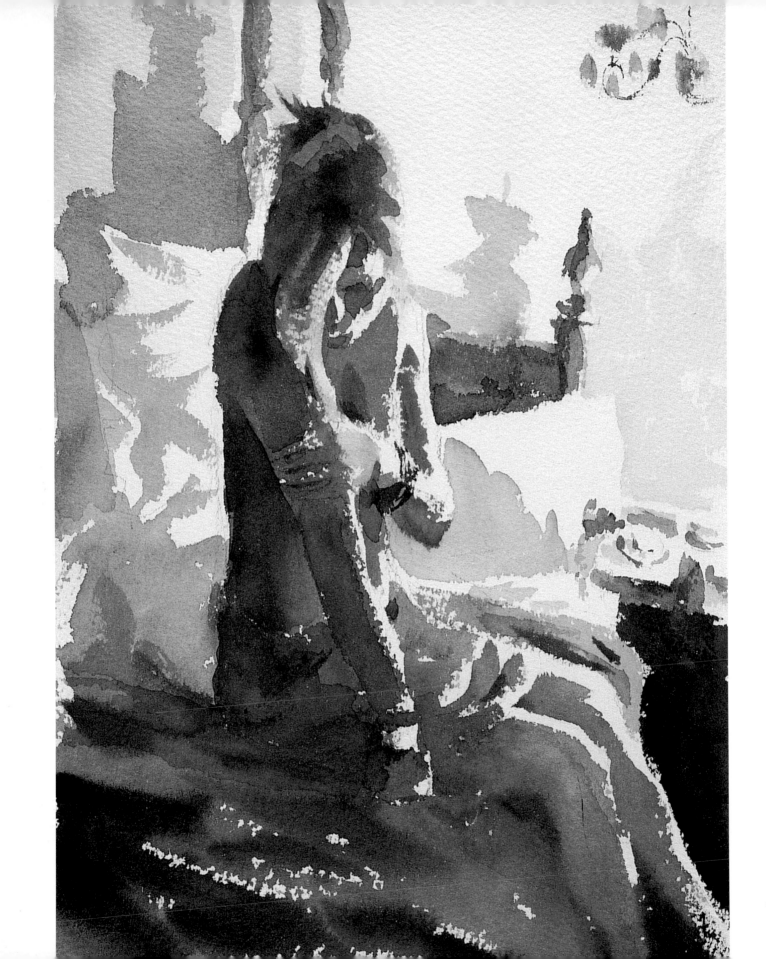

Contrast

The greater the contrast of tone between the highlight and its surrounding shade the brighter the highlight will appear. Once again boldness is rewarded – try to paint the right tone adjacent to your highlight with the first brushstrokes to avoid multiple edges. The irregularity of the edge of the fresh brushstroke is more appealing than repeated layers.

Tinted Light

Light is tinted by the colour of its source – a setting sun will bathe the landscape in golden light, a rising sun will throw a rosy glow. The light can be tinted with glazes of diluted colour over the reserved white paper highlights or an appropriate tint can be laid as an undertone before painting on top. Colours with transparent properties will have greater radiance than the opaque ones – for example, use Indian Yellow (T) for a golden sun rather than Cadmium Yellow (O), and for more gentle tints use a dilute semi-opaque colour such as Yellow Ochre or Cobalt Blue.

◁ **Bathed in Light**
25 x 20 cm (10 x 8 in)
The direct contrast between the radiant shades and the bright highlights ensures a vibrant light glows in this painting.

Gliding on Mirrors
23 x 28 cm (9 x 11 in)
An undertone of Raw Umber tints the buildings with a warm glow and an overtone of Raw Umber links the water to the sky.

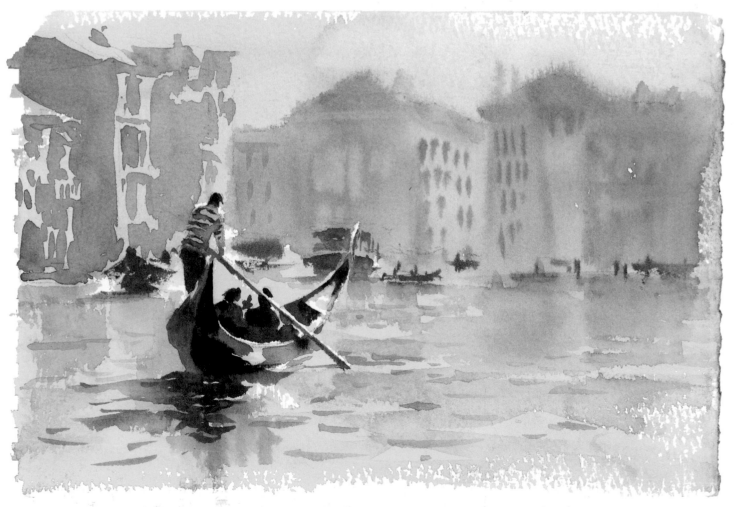

White Paint

White paint can be used to create small highlights in a painting. Paint them at the end so as not to cloud the water. White glazes can also be used to mute brightness. White paint never provides as bright a light as the virgin paper, but for small areas of highlight, narrow lines and flecks of light it is ideal and saves worrying about finicky details during washes. Chinese White is the most popular white; it is semi-opaque and has a blue undertone, ideal for dulling colour mixes during painting. Titanium White is fully opaque and has greater covering power than Chinese White.

Unfurling
10 x 10 cm (4 x 4 in)
The smoke curling from the cigar was painted with Chinese White in differing strengths of concentration.

The Boy in the Red Sweater
20 x 28 cm (8 x 11 in)
Titanium White can be used to restore highlights, like those on the fountain and tree trunks in painting.

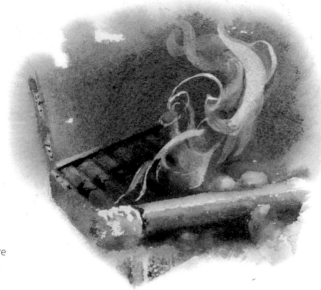

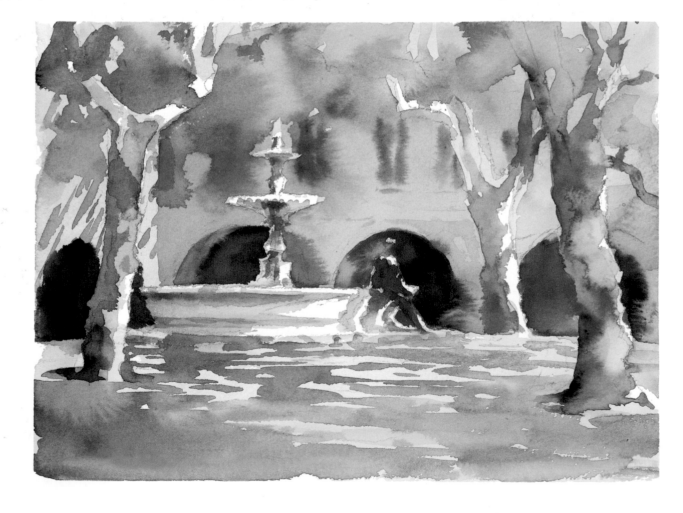

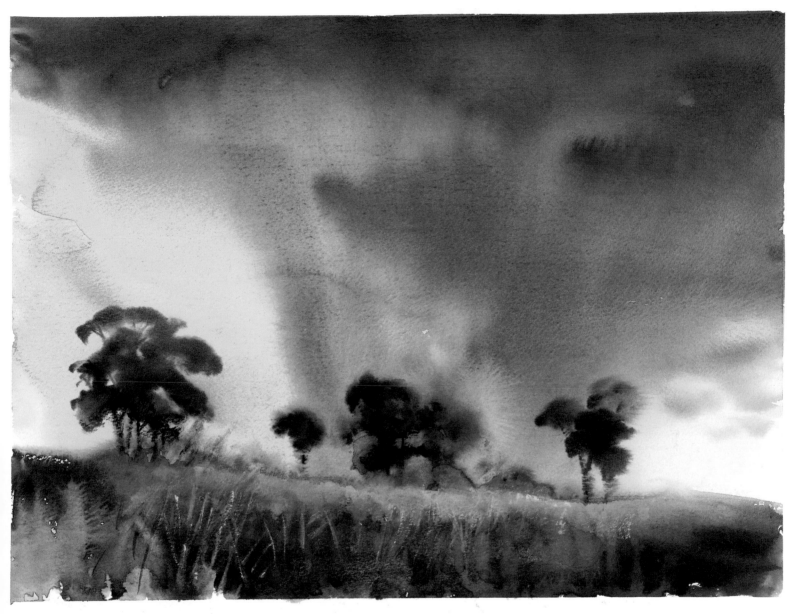

Coloured Opaques

All the opaque pigments have good covering power, which means they can, in concentrated form, obliterate the colour they cover. Used neat from the tube or pan, they can be used to paint coloured highlights on to dark passages of colour, for example in foliage. For warm highlights use Cadmium Yellow and Cadmium Orange; for cool highlights use Lemon Yellow and Cerulean Blue.

You can create your own opaque colours by mixing transparent colour with white. To resurrect a glowing highlight lay a glaze over dried white paint, as if you were tinting the virgin paper.

The Prophets in the Clouds
30 x 35.5 cm (12 x 14 in)
Opaque Cadmium and Lemon Yellow brought back the eerie yellow light under the stormy squall, which has been lost when the field was painted too dark.

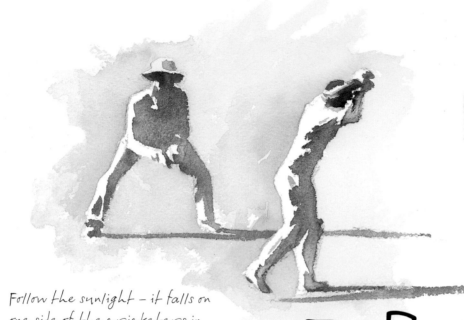

The luminous moon needs the dark surround to be able to shine.

Follow the sunlight – it falls on one side of the cricketers in the morning ...

EXPLORE!
Light

... and lights the other in the afternoon.

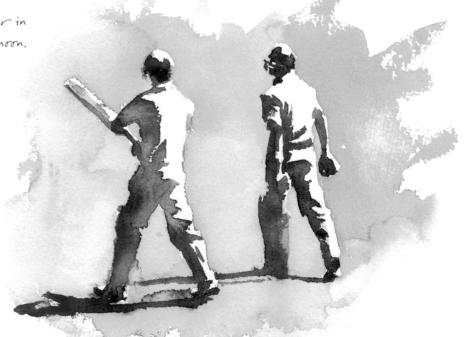

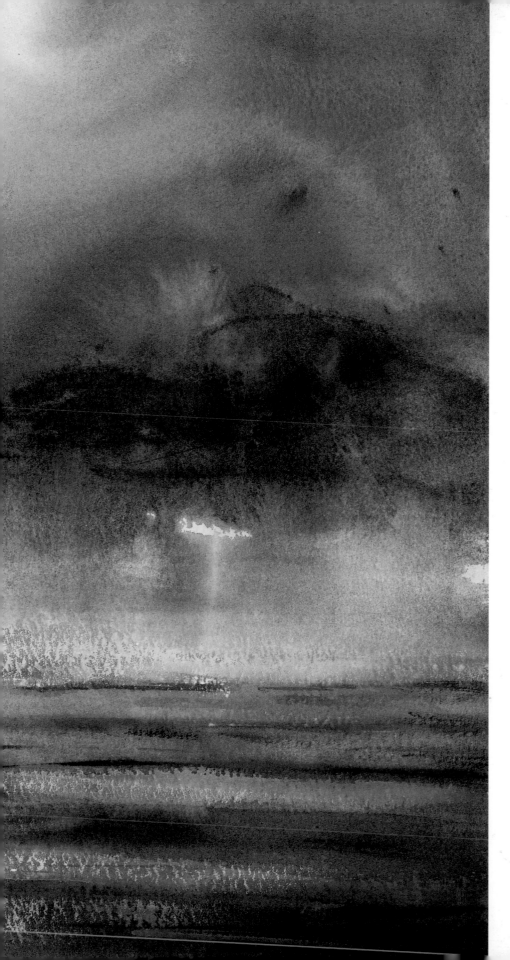

6 Open for Manipulation

The freshness and immediacy of watercolour is its chief appeal and because this aspect is easy to lose it has earned a reputation as an unforgiving medium. However, once you understand what can and cannot be corrected you will find it is actually more forgiving than is commonly thought. Paintings that seemed lost can often be manipulated safely back to success. Knowing what constitutes a problem, and what does not, is the key – when to correct and when to give up! The attraction of a watercolour is in its appearance more than its content, so always put the 'look' of the watercolour before the accurate rendition of the subject.

Riders in the Storm
35.5 x 51 cm (14 x 20 in)
The light on the wet beach is entirely created by scratching off the pigment to reveal the white paper.

Freshness Matters

In previous chapters you have seen how important fresh and immediate application is to the appeal of a watercolour painting – the strength of a watercolour is found in the clarity of the initial washes. The more you try to coerce watercolour the more it resists. The areas of blended pigment are the essence of watercolour; they are its characteristic action when laid and allowed to flow unmolested, so it goes without saying that these are the areas hardest to engineer if they go wrong. The small areas of a painting, on the other hand, which bring tonal variety and vitality can much more easily be tampered with without ruining the watercolour. During a painting do not worry about details – they can be corrected – but concentrate on the washed blends and above all do not destroy a lovely passage of watercolour for the sake of likeness to the subject.

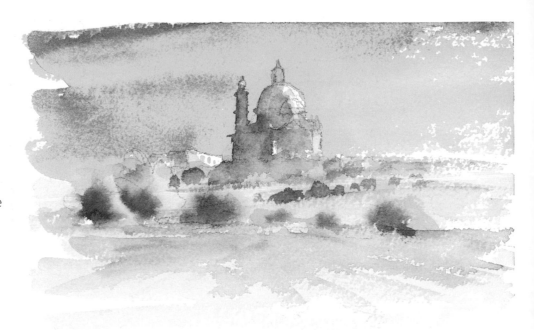

△ The fresh immediacy of this unfiddled-with watercolour sketch is more appealing than it would have been had I tried to correct the accuracy of the view.

▽ Unintended backruns end up making entertaining rain clouds – better left alone than trying to coerce them!

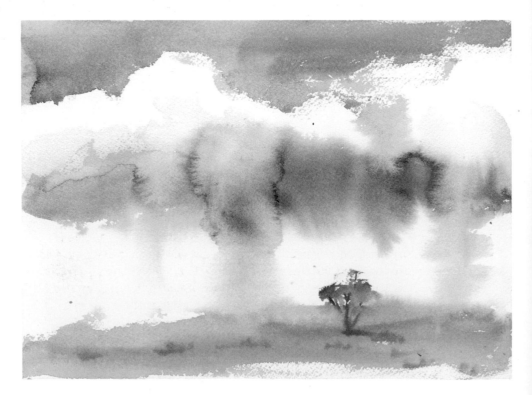

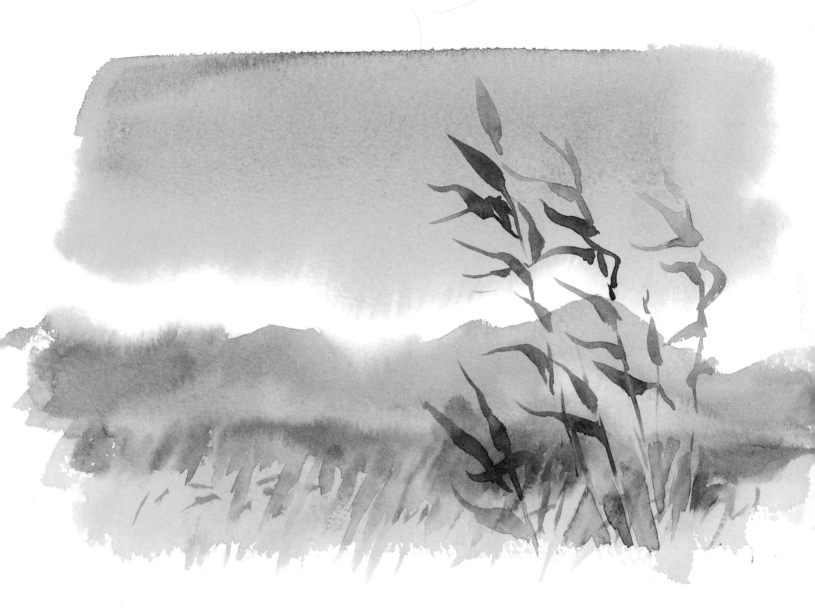

The Art of Distraction

Errors or aberrations in light-toned early washes are not a problem. As soon as darker tones are employed the eye is distracted from the pale tones. So there is no need to worry about an imperfect sky wash – leave well alone, and do not fiddle or try to correct or you will only draw attention to it. If at the end of a painting the part that bothers you is still glaring (to others, not to you, since it will always be obvious to you) you may be able to lift it out or disguise it with the application of opaque paint. Often the simple use of a dark-toned accent nearby is enough to distract the eye away from the problem.

If all else fails, resort to an ingenious title to guide the viewer towards some philosophical thought or to direct them to something you do like in the painting!

From this very simple sketch it is plain to see how easily the eye can be distracted from the background landscape by the addition of some darker brushstrokes, in the form of reeds, strategically placed across the image.

To Touch or Not to Touch

Since you are the creator of the painting you will always see the errors and irritations. I have a motto to prevent me making needless brushstrokes and corrections – 'if in doubt, chicken out'. Before attempting to correct an issue confirm that it is indeed causing a problem. You can try to judge impartially by viewing the painting in reverse in a mirror; however, you will need to be very disciplined not to home in on the area in question at first glance. A sympathetic critic can be helpful, but the distance created by time is usually the best judge of all. When you next view your painting, if the error immediately sticks out, you know it needs attention but if it is not the first thing you notice, leave well alone. You will always regret needless fiddling.

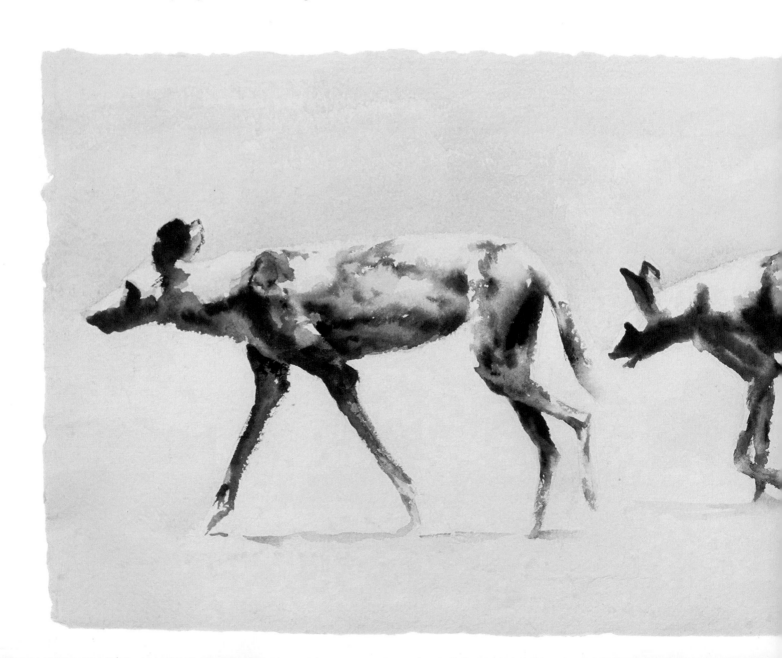

Problem or Opportunity?

Anomalies in a freshly laid wash are best left alone until the end of a painting. Small gaps in the wash or concentrations of unmixed pigment can be rectified later. Avoid the temptation to fill them in or ease them out while the wash is drying. Since most large washes are made at the beginning of a painting the chances are that the 'errors' will go undetected once the darker tones are in place. Sometimes what you may think is messy in the early wash turns out to be a plus later, so do not judge your work too soon. If the 'gaps' in a wash need 'filling' mix pigment to the same colour and tone and spot-fill them carefully at the end, as if you were restoring a painting. Excess pigment marks can usually be lifted out with the tip of the brush or disguised with a precisely placed tint of Chinese White.

Wild Dogs
35.5 x 99 cm (14 x 39 in)
The hind legs of the last wild dog were repainted to correct an initial, impossibly stretched, pose. The corrected legs distract the eye from the sponged-off legs and these now serve to enhance a feeling of movement, as if the dog has just moved forward.

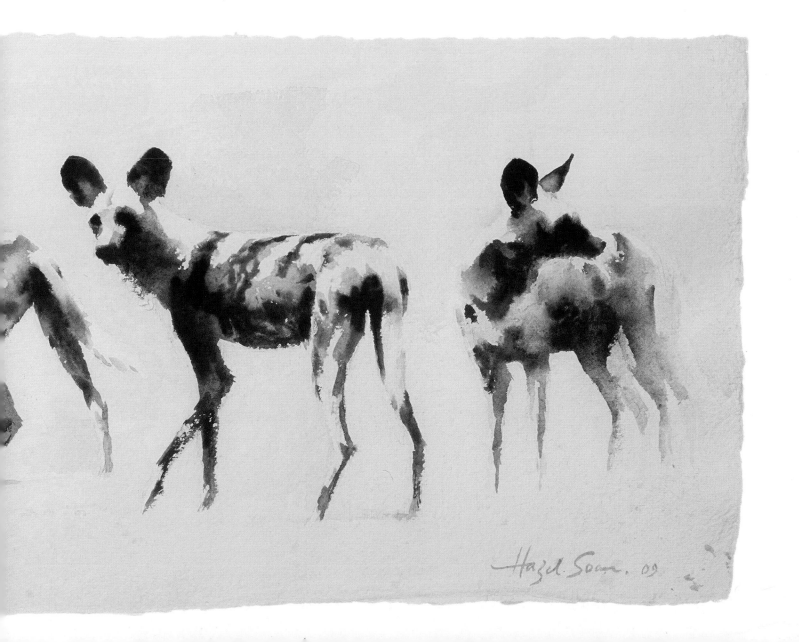

Lifting Out

To a large degree watercolour pigment can be lifted or washed off the surface of the paper with the use of a clean, damp brush or a clean, damp sponge. Many watercolours have staining properties, so they leave a light trace on the paper, but since darker tones distract the eye from paler tones, the removal of excessive pigment in this way may often cure a jarring colour or tone. Some watercolours are not staining colours, most notably Ultramarine Blue and Burnt Sienna, and these can be lifted off in their entirety from a good-quality paper.

If a pigment is a lifting colour it follows that it can also be disturbed by subsequent layers of wet paint or by wetting with clean water. Be gentle and thrifty with your brushstrokes when painting over lifting colours so that you do not disturb them and end up with muddied colour.

A sponge swiped across a swatch of Ultramarine Blue easily lifts off the colour.

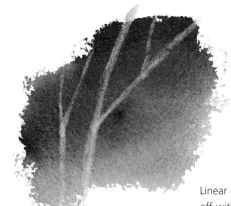

Linear details such as branches can be lifted off with the tip of a clean, damp brush in a patch of Burnt Sienna and Ultramarine Blue.

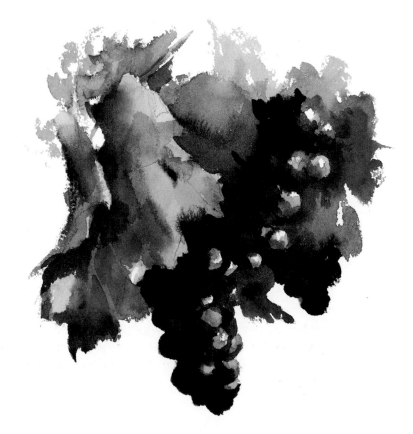

Ultramarine Blue, a lifting colour, was used in a mix with Alizarin Crimson and Burnt Umber to make the black of the grapes. This allowed the retrieval of light on the grapes, lost in the initial fast-drying wash, by lifting off the paint with a clean, damp brush and kitchen towel.

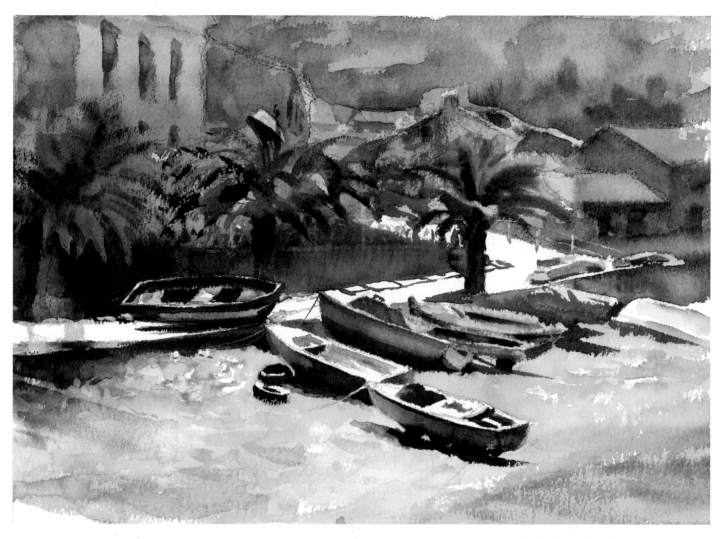

Opaques to the Rescue

Opaque colours have covering power, so they can be used to restore lost highlights, or lighten persistent darks that cannot be lifted off. The provocative edges of backruns can also be cleverly disguised by overpainting the irregular line with Chinese White applied with a small brush. This may take some time to get to the right tone (often longer than actually painting the painting again!), but it is a worthwhile repair if the rest of the painting works well. White dries less opaque than it looks, so it may take several attempts to reach the same tone as the surrounding area either side of the line. Wait for each application to dry before applying the next.

Errors of shape can also be 're-drawn' at the end of a painting by obliterating the transgression with opaque colour, particularly where lifting off would be dangerous to the surrounding washes. If the shape is against white paper the application of concentrated Titanium White easily disguises the error and no one but you will notice. If the background is coloured, choose or mix a matching opaque.

Zig-zag Light, Collioure
28 x 35.5 cm (11 x 14 in)
Opaque White and Cadmium Yellow are used neat from the tube to reshape the lightest palm leaves lost amid the background washes.

Scratching Off

One of the ways to restore virgin white paper is to scratch off the top surface with a sharp blade, and this method is especially effective on heavy papers. The stain of pigment can be completely removed and untouched paper revealed. Make sure the paper is completely dry to avoid tearing and do this only when you have finished applying wet paint as the exposed area becomes like blotting paper where the gelatine size has been scratched away.

A Bigger Splash
46 x 102 cm (18 x 40 in)
Several of the white-paper highlights in the water between the elephants' feet were retrieved by scratching off the painted surface of the heavy khadi paper with a sharp blade.

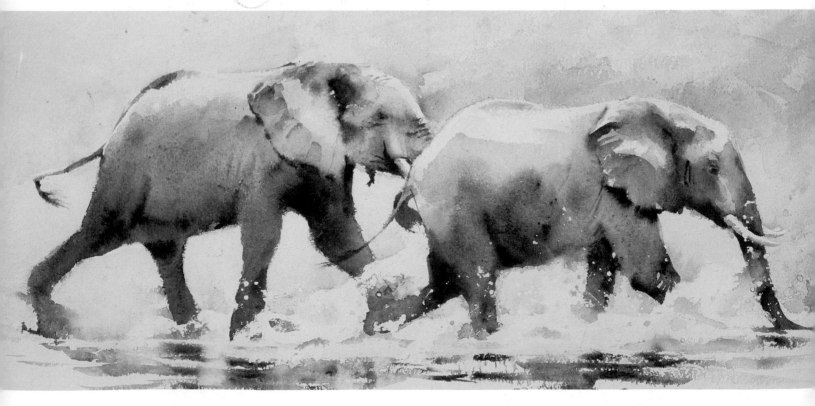

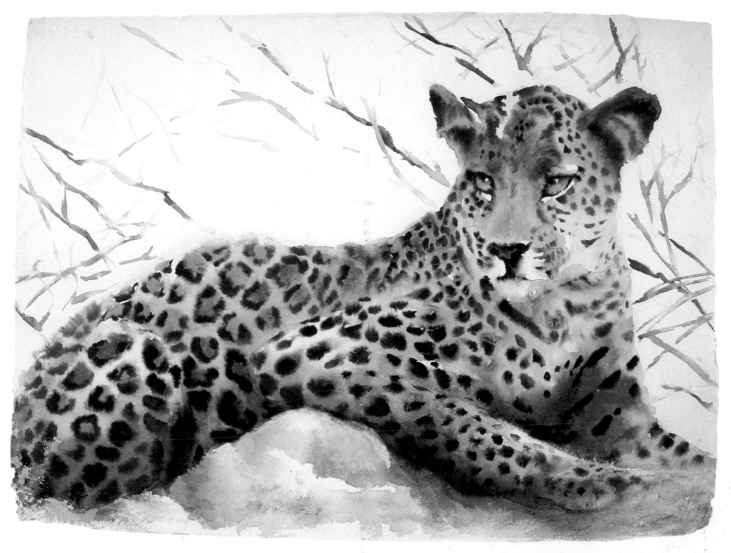

Coloured Crayons

The problems of a painting are often to do with misjudged tones and the correct tone may be hard to assess. Repeatedly applying layers of tints in the vain hope of reaching the right tonal strength may serve to deaden the colour. Instead you can use coloured crayons to find the right tone, then rub them off and apply the same tone in paint. If the coloured crayon does the job perfectly and the texture looks acceptable on the watercolour you can even leave it in place.

You can also use a coloured crayon or soft pencil when deciding if a form needs a dark edge or outline. If not, it is easily erased.

Feline
56 x 76 cm (22 x 30 in)
Coloured crayon was used on the foremost leg
to darken the tone gently and give it texture.

Wait Till the End

Do not be in a hurry to correct your mistakes. Most of the manipulations in this chapter can only be done at the end of a painting – the early introduction of concentrated opaque colours would muddy subsequent layers; scratching off creates blotting paper; and the erasure of coloured crayons scuffs the surface. Besides, how do you know which mistake matters until the end of the painting is reached? Maintaining the integrity of the paper surface is crucial to dynamic brushstrokes and attractive washes, so be patient, trust the watercolour medium and only pass your final judgement when you feel you are nearing the conclusion of the painting.

Underground Movement
28 x 35.5 cm (11 x 14 in)
The large backrun in the wash on the right of the platform seemed so horribly wrong before the figures were added, but it ceases to matter in the finished painting.

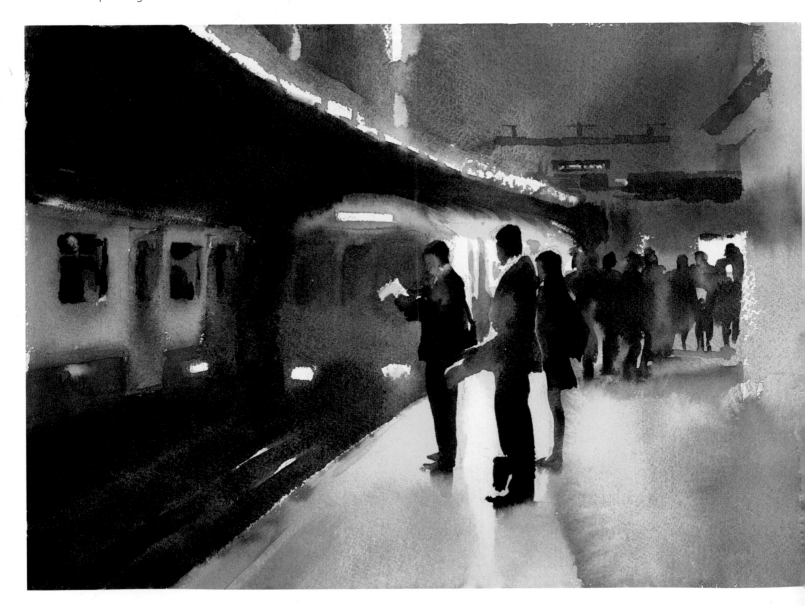

Beyond Redemption

Some watercolour mistakes are irredeemable. If a painting is overworked and transparency lost it is hard to regain freshness. At other times it is a matter of available time – it may take an hour or two to paint a watercolour, but it can take a whole day to put it right. So sometimes it is better to abandon a painting and start over again, to waste paper rather than time. The beauty of paper is that it can also be cropped, so if there are watercolour passages in a failed painting that do have life simply cut away the dross and preserve the good section. Watercolour is so lovely in itself that even small fragments have great appeal.

Fragments of a Garden
30 x 30cm (12 x 12in)
Even in failed paintings there are often passages of attractive watercolour. Putting a selection of these together in a group can create an interesting image.

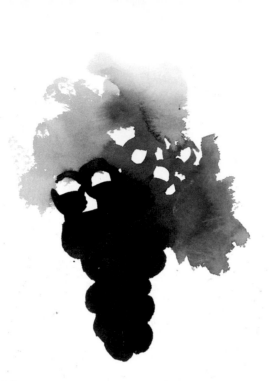

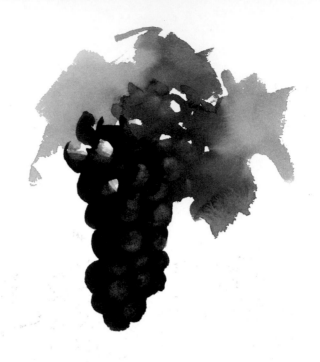

Make a black with a mix that includes Ultramarine Blue. Lift out the lighter tones with a damp brush, and voilà, the grapes appear!

EXPLORE!
Manipulative Techniques

Choose a brightly coloured flower to practise pushing back an invasive colour with an opaque. Here violet is pushed back and overcome with opaque Cadmium Yellow.

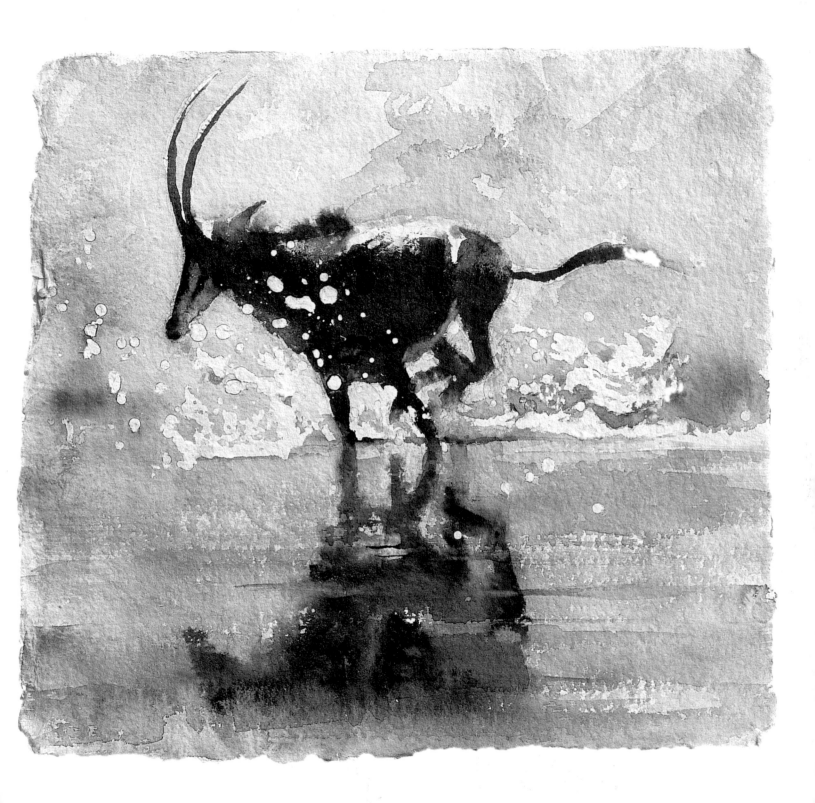

Working on a heavy paper with a sharp blade, boldly scratch off the painted surface to suggest splashes of water.

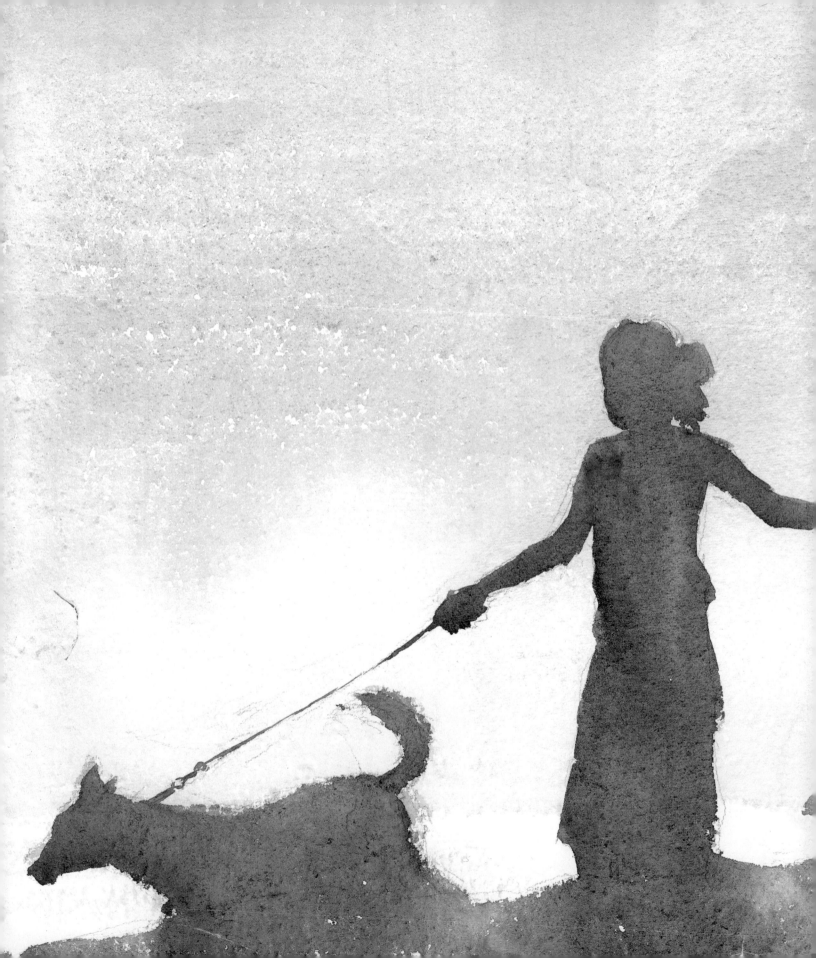

7 The Kiss of Simplicity

The essential beauty of watercolour is found in the medium itself. A directness of approach more readily displays the qualities of transparency, brilliance and radiance than a cluttered statement. Knowing your focus and selecting what matters gives clarity of purpose to the mixing and brushwork. Watercolour painting is challenging, so keep things as simple as possible and you will create paintings that allow watercolour the chance to show off all it can do.

Links of Trust
38 x 56 cm (15 x 22 in)
The meaning in an image is clearer to read
if the content and style are kept simple.

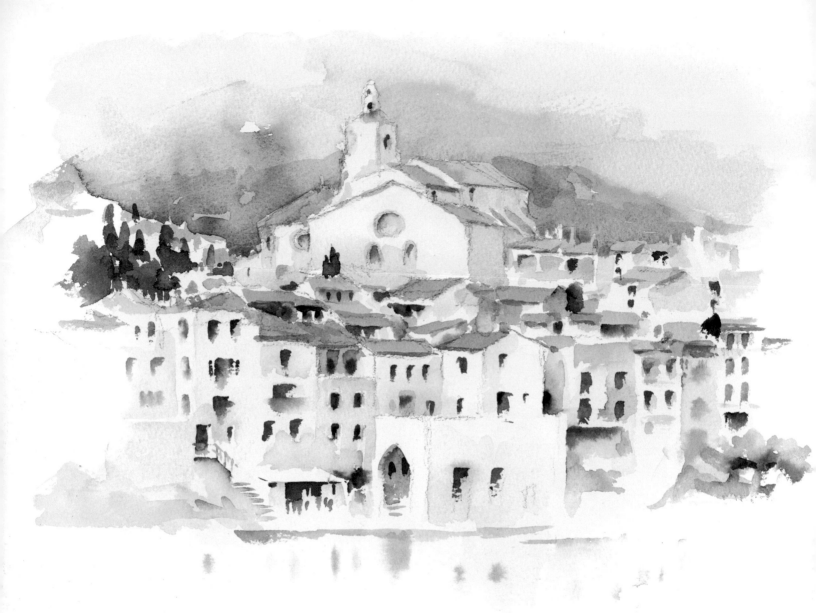

Knowing Your Focus

White On White, Cadaqués
35.5 x 48 cm (14 x 19 in)
With only an hour's painting time available,
a complex scene was distilled by choosing
the church as the focal point and working
outwards from there.

The focus of a painting is usually whatever attracted you to paint it in the first
instant. It could be a physical feature, such as the shape of a tree, person or object,
it could be the light falling on the feature or scene, or it could be something less
tangible such as atmosphere or mood. Because painting takes time it is easy to
lose sight of the original focus as the painting proceeds and all too often the reason
for the painting is overtaken by other concerns such as accurate rendition. A good
practice is to write down the focus at the start; this may change during the painting
as something of greater interest arises, but the important point is to know what
attracts you. This will help you judge when your painting is finished, which is
one of the hardest aspects of painting.

Selection

A photographer trains the focus of the camera lens on the focal point of the composition. The rest of the image may be in or out of focus depending on the depth of field. Everything in the view is recorded, whether it helps or hinders the composition, and only with a sophisticated camera or software can this be manipulated. The painter has a huge advantage in being able to direct the eye by emphasis, to leave out extraneous material and to open or close the spaces between objects or features to strengthen composition. When painting from life, this selective process occurs naturally since the painter is forced to reduce the real world to the size of the paper, and the vagaries of changing light put constraints on time. When photographic reference is the source of the painting the danger is to include everything, so you have to decide what to put in and what to leave out. How many times have I heard 'well, it was there' as the excuse for the inclusion of a particular feature that clearly does not benefit the painting!

Pienza
25 x 35.5 cm (10 x 14 in)
The attraction here was the light on the white umbrellas. By homing in on the small group of people having lunch, vastly reducing the number of chairs and tables, and even losing one umbrella, the watercolour became much more manageable.

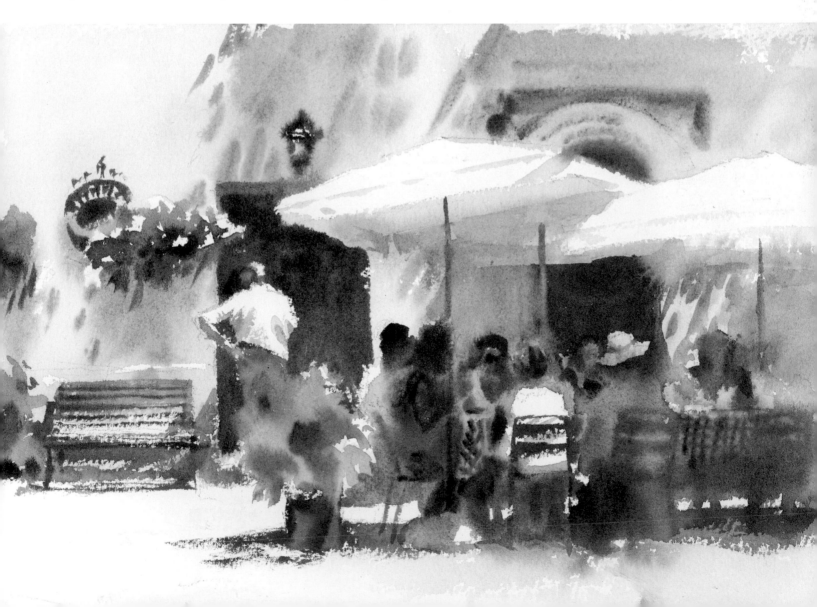

Making Decisions

How do you select what matters and what can be left out? When your inspiration is a ready-made composition it ignites the urge to paint because it is already a good balance of tone, colour, line and shape. You can make the selection process by simply screwing up your eyes and concentrating on the main tones – highlights jump out, mid tones unite, shadows blend and irrelevant details vanish. As you paint, avoid being swamped by the detail. If the inspiration is a particular feature in a view you need to decide which parts of the view serve the feature and which distract from it. You may need to generalize or simplify the background so that it serves purely to bring the foreground feature into existence on the page.

△ This is a hugely simplified sketch of what was actually a complicated, messy scene with many trees and myriad lights dancing on giant boughs. Looking through screwed-up eyes, the main lights and shadows only were selected, in order to manage the composition.

▽ **The Fountain, Uzès**
20 x 28 cm (8 x 11 in)
The square was teeming with people, but deciding on one figure, perched on the rim of the fountain, was enough. The addition of more figures would have distracted from the dappled shadows on the ground, which were the attraction in the first place.

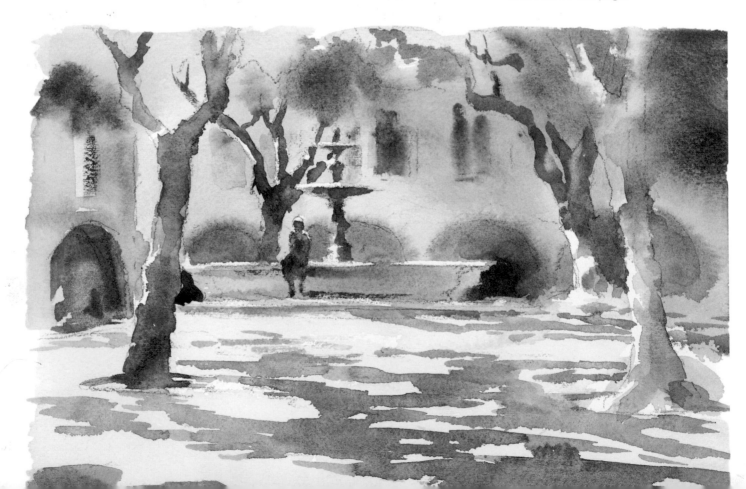

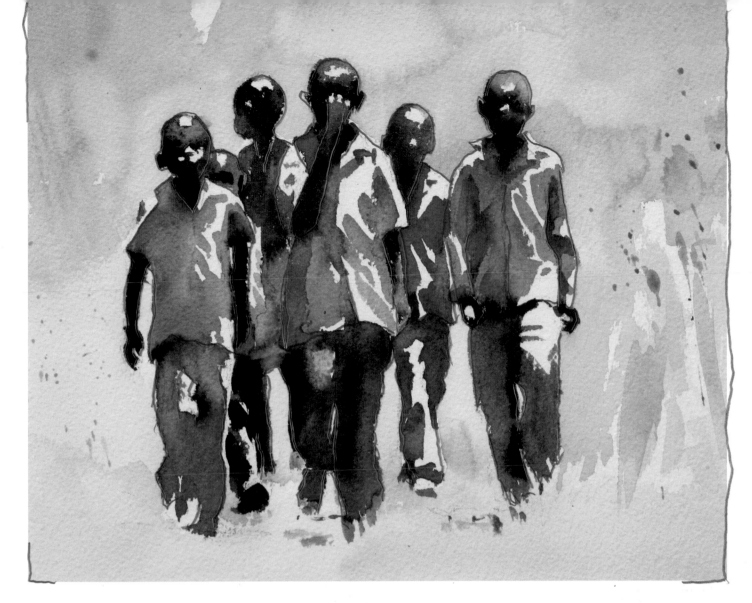

Uniquely You

Being an artist all comes down to what excites you and what you want to paint. Your task as a figurative artist is to follow the rules that govern the formal elements of painting – shape, lines, colours and tones – in so far as they serve your purpose. The visual world is your inspiration, not your master, so take from the subject only what you want.

A watercolour does not have to have a background, a sky does not have to be blue, legs do not have to have feet. As soon as you realize that your only obligation is to your own inspiration you are free to leave out all the rest.

One of the joys of watercolour painting is that you can produce meaningful paintings at speed and on quite a small scale. This also releases you from having to say everything in the one painting – you can paint the same thing over and over again with different emphases. We cannot re-create the world, but we can re-create our own images of it.

March of Education
23 x 30 cm (9 x 12 in)
This is one of a whole series of paintings of school children in Namibia. I just couldn't get enough of the joy and hope I witnessed as they poured out of school, lining the roads with their optimism.

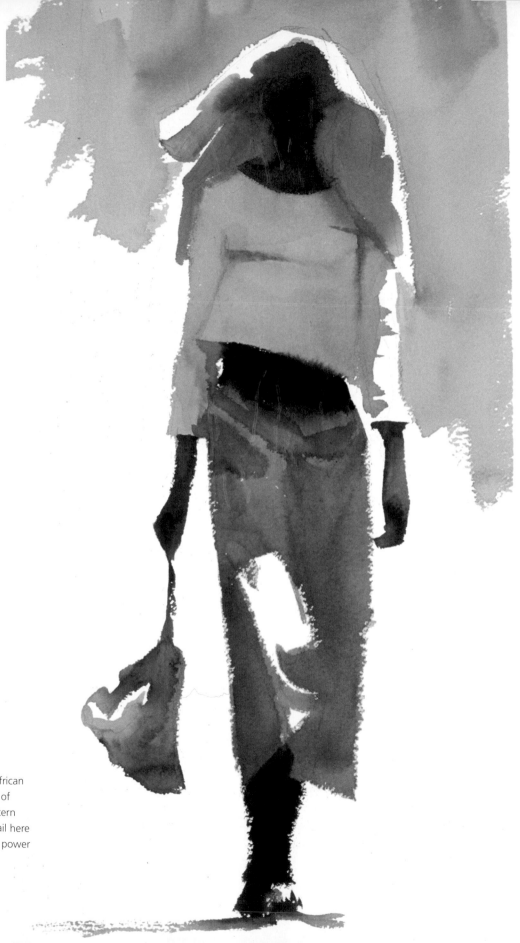

Heat of the Day
46 x 23 cm (18 x 9 in)

The searing heat on a girl walking an African road is evoked by a few simple patches of coloured tone, strung together in a pattern of light and shade. There is so little detail here and yet the narrative is clear. This is the power of watercolour.

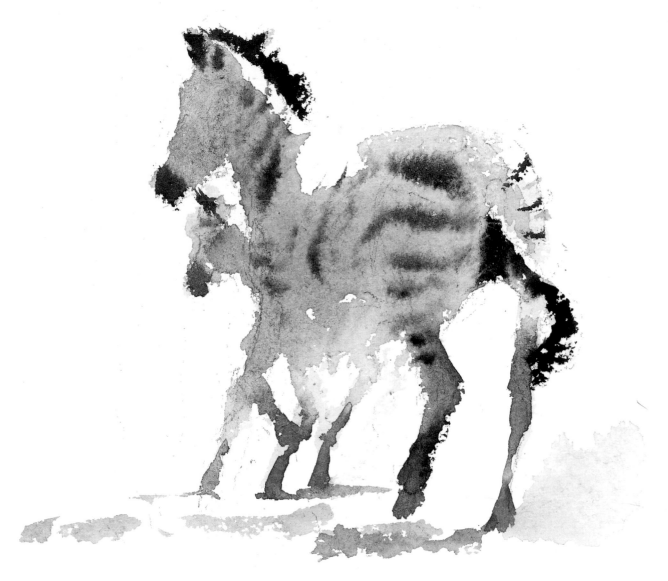

Less Is More

The medium of watercolour is so lovely in itself that to overwork it is a waste of its greatest assets. The adage 'less is more' is particularly pertinent for this medium, where adding 'more' may often make it less appealing. Concentrate on transparency of colour, and make radiant blends your focus. A simple composition has just as much merit as a complex view. Learn to see fragments of views or select something from within a view that makes a good composition in its own right. Then simplify even that. Think of your painting as a form of shorthand and see how much you can suggest with a few strokes. You will be surprised how little paint you need to convince a viewer of something's existence. It is a matter of changing your thinking so that you use the subject to paint the watercolour rather than the watercolour to paint the subject.

Watercolour has the ability to say a lot with a few strokes. Here the baby zebra is barely indicated, but we know it is there hiding under its mother's protection.

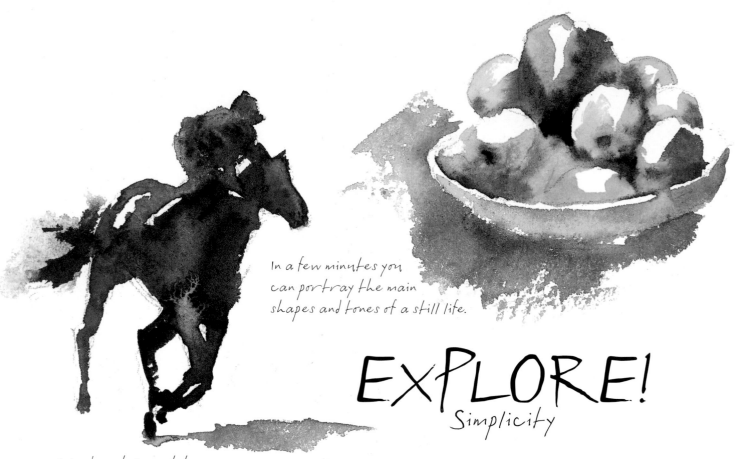

In a few minutes you can portray the main shapes and tones of a still life.

EXPLORE!
Simplicity

Work wet-in-wet to suggest complex movement.

Observe objects from a distance to force simplification.

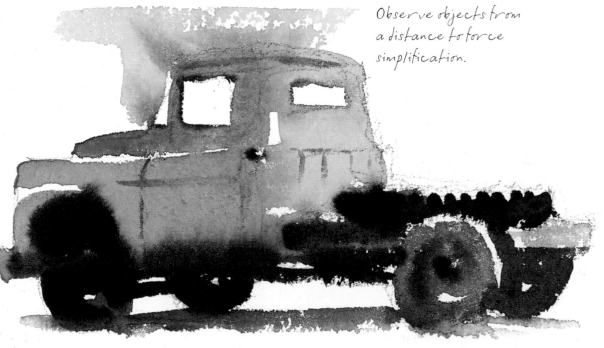

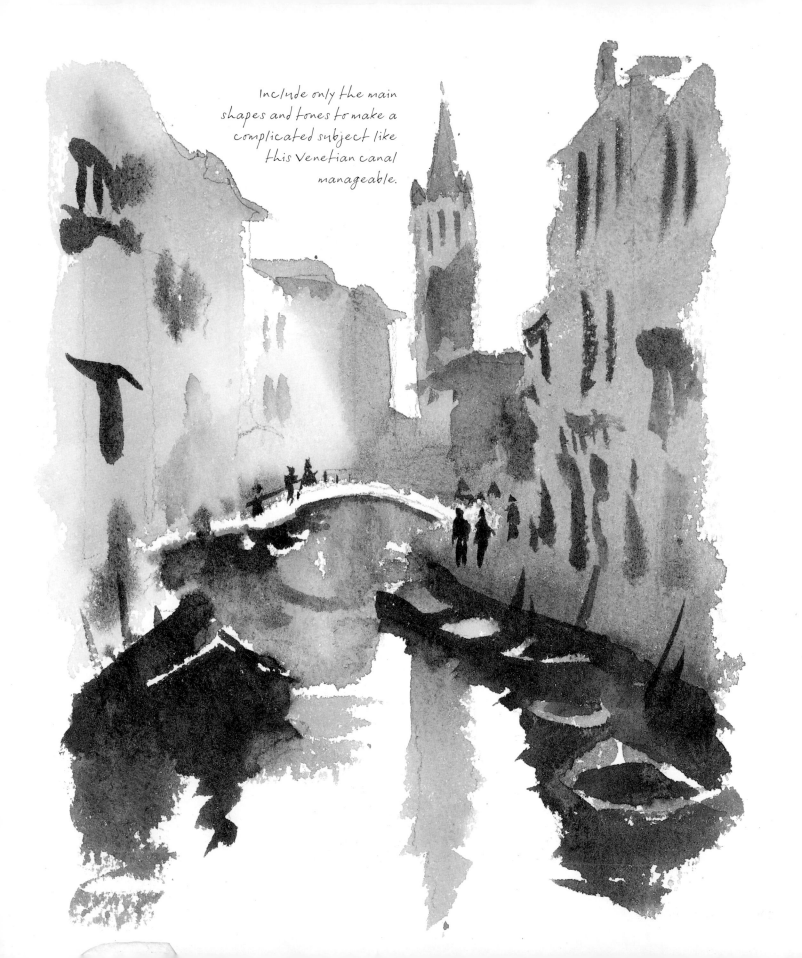

Include only the main shapes and tones to make a complicated subject like this Venetian canal manageable.

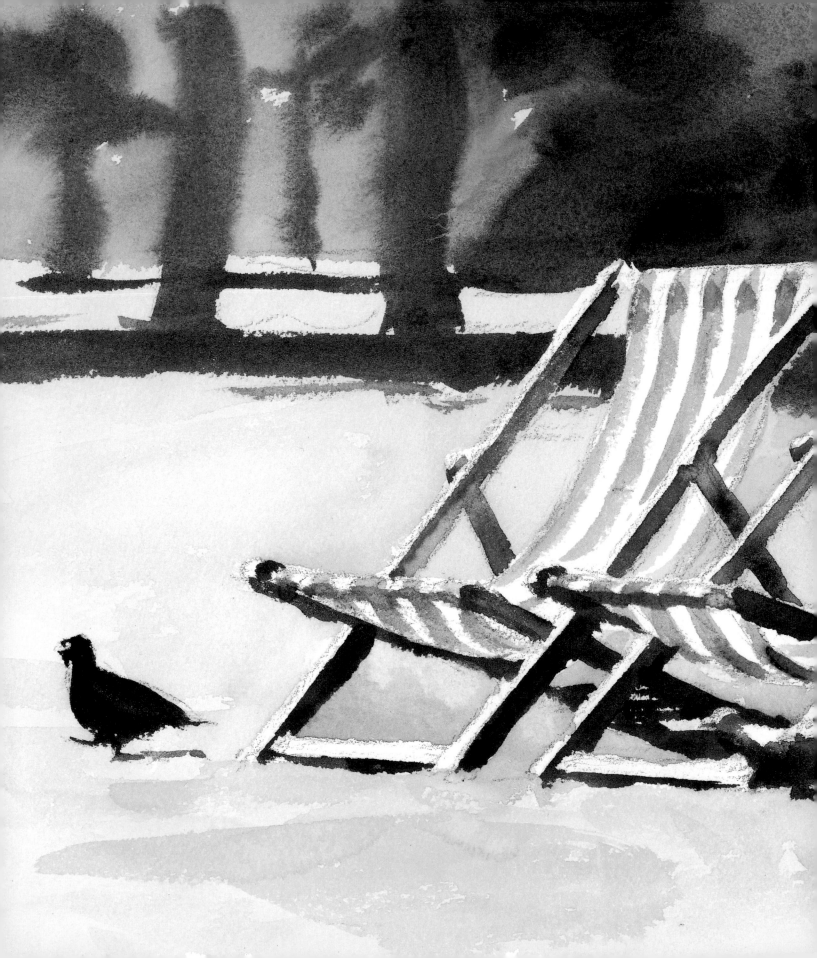

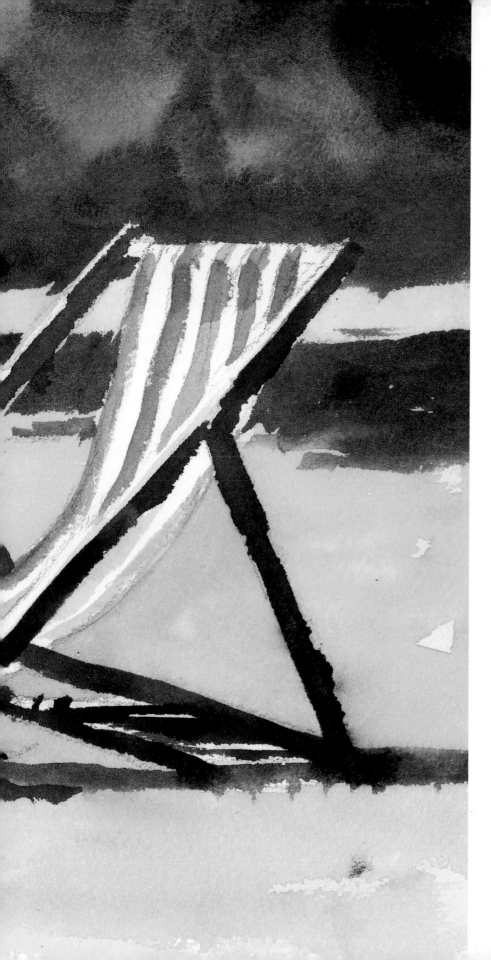

Learning to See

Watercolour is such a wonderful medium to paint with that even by default a total beginner can make delicious blends of colour and lively brushstrokes, and experience great satisfaction in painting. Those who have worked with it for a while know it is a challenging medium, requiring thought and planning. However well you mix, lay and blend it, watercolour requires an artist's eye to bring out its best qualities.

Vacant Spaces
28 x 35.5 cm (11 x 14 in)
These deck chairs are painted by drawing the shapes of the spaces between the framework rather than the chairs themselves.

The Painter's World Is Flat

Painting is a two-dimensional interpretation of the three-dimensional world. However accurately an object is portrayed, it can never be that object; it will always be a painting. This is great news because as an artist you have no obligation to make a landscape look like a landscape or a person look like a person; your only obligation is to make a painting look like a painting. You are free to translate three dimensions into two dimensions and get a kick out of doing so. In figurative painting the artist uses tone and perspective to suggest that three dimensions exist on the flat page, but these are merely tools of illusion and can be manipulated to enhance the painted surface. However deep the meaning, or profound the content, paintings are made up of shape, colour, line and tone, the formal elements of painting. By using perspective, contrast and measurement an artist plays make-believe with paint. Just as music is made up of many different notes played side by side, so painting is composed of brushstrokes, placed side by side, interlaced and overlaid. The more pertinent the strokes, the more meaningful the result.

Desert Lines

25 x 100 cm (10 x 39 in)

This painting of wildebeest on the move is reminiscent of the cave paintings of early man. We have always had the desire to represent our world in two dimensions.

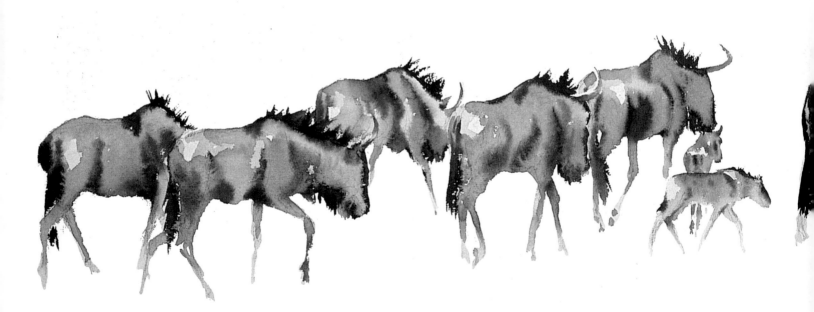

Everything Is Relative

Once you are seeing the world through a painter's eyes, looking at the things a painting needs – shape, tone, line, colour – you will find a whole new delight in the perception of your eyes. Everything is only what it is in relation to its neighbour. No colour or tone is absolute. Each affects those around it and the image as a whole. This means you need to see the relationships between features and objects rather than considering them in isolation. This is the painter's delight and a never-ending source of inspiration.

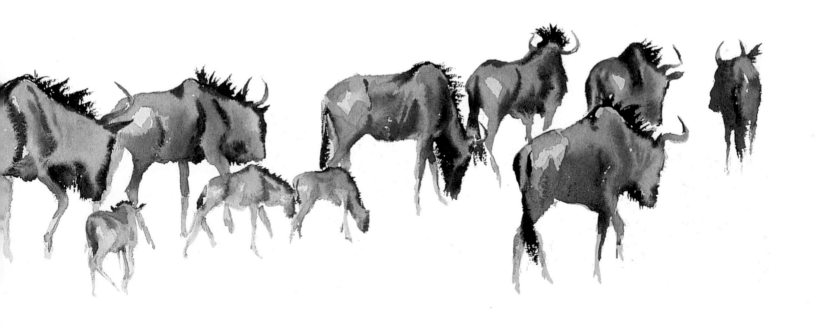

Relative Tone

Just as a musician can hear minute changes in the nuances of sound, so too an artist notes the countless adjustments of tone that play across a scene. The beauty of watercolour is that the natural gradation of blending colours and the assimilation of overlapping tints create these myriad tones for the artist, but they need to be acknowledged before they can be interpreted. The best way to teach the eye to read tone is to practise with slices of a view. Lead the eye slowly across a section, assessing the relative tonal values as lighter than, darker than, much darker than, less light than, and so on. Train the eye to be rigorous in working out if a tone is lighter or darker than its neighbour, and half close your eyes to help decide. View a scene through polarized sunglasses to define similar tones. Turn this observation into practice by painting simple items on to white paper with attention to tone. Once you can see the innumerable changes, start to simplify the tones into bands of relative value – lights, mid tones and darks.

Mediterranean Geometry, Collioure
20 x 28 cm (8 x 11 in)
The facets of cuboid Mediterranean buildings fall into basic geometric shapes – squares, parallelograms, trapeziums. Those facing in a similar direction will receive a comparable light and so be analogous in tone.

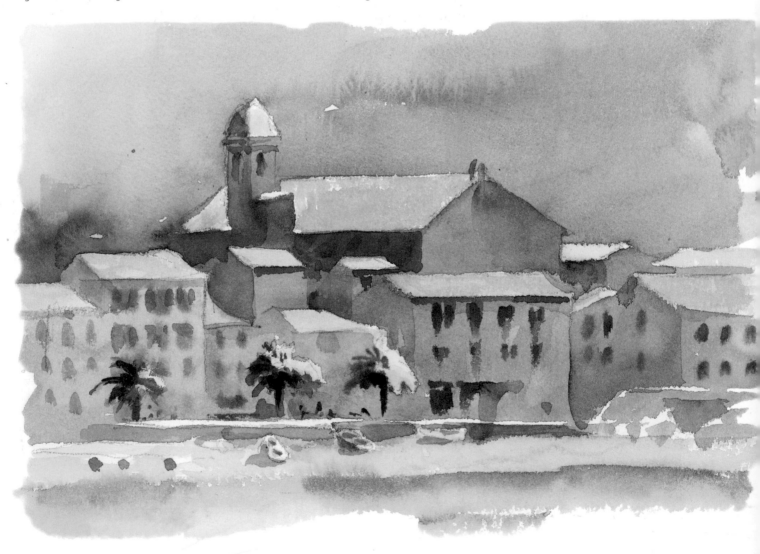

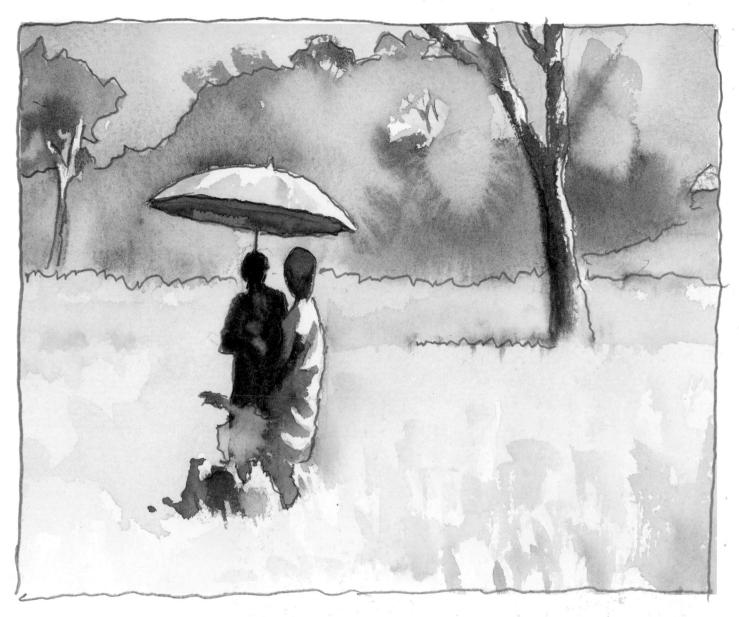

Light Against Dark, Dark Against Light

An exciting composition rests on a contrast or variety of relative tone. The eye
need never be bored – try whiling away a lengthy stay in a waiting room by simply
moving your head up and down to view a window frame against an alternating
background. The bar could be dark against a light sky, but if you lower your head it
may become light against dark trees. Thus you will gradually realize that all tone is
relative; the window frame is neither light nor dark in itself but only in relation to
what it is set against. This simple realization holds the essence of learning to paint
adjacent tones. A background is only useful in so far as it sustains the foreground –
a shaded side of an object is set against a lighter-toned background and a lit side is
made apparent by a darker tone beside it.

Bus Stop
20 x 28 cm (8 x 11 in)

The two ladies merge together as one shape,
setting up an attractive tonal exchange on
either side: light against the comparably darker
tone of the yellow grass on the right, dark
against the light grass on the left.

The Spaces Between

The painter learns to see by shape and tone. The spaces between and around objects are as valuable to the suggestion of forms on the flat painted surface as the shapes and tones of the physical objects themselves.

Seeing the spaces between objects is a good way to start learning to see as an artist. Observe items such as chairs and tables and paint them purely by painting the spaces between their legs and rungs. Go into the park and look at the intervals between a line of trees, and at the spaces between people in groups, sitting on a bench or standing talking. Observe the triangular gaps between striding legs, the triangle below the knee as walking legs cross. Note the spaces between the body and crooked arms, and between branches and foliage. Spend your time looking at the spaces between things and whenever possible draw them, because you never truly know what something looks like until you draw it. Once this way of seeing becomes habitual you will find it much easier to translate the three-dimensional world on to flat paper.

Diamond of the Delta
20 x 28 cm (8 x 11 in)
In this painting of an Okavango lily you can clearly see that the triangular spaces between the opening petals are as important in making their shapes as the triangular spaces of white paper left between them.

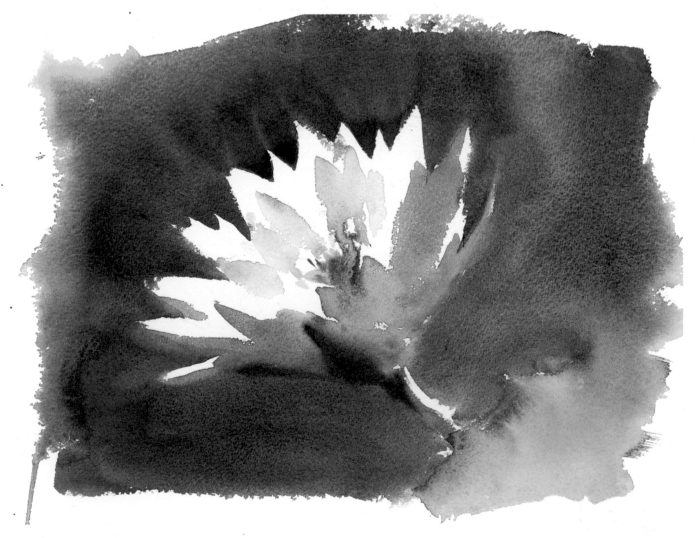

Positive Marks and Negative Shapes

To create an image in the transparent medium of watercolour the artist has a choice between making positive brushstrokes and leaving negative spaces – that is, leaving gaps in a wash, or painting around a shape. The tone of the background determines this choice of mark. If an object is darker than the background, a positive brushstroke will bring the object into being; if the background is darker, then the shape of the object must be omitted from the surrounding wash, making a negative shape. Spaces between objects may be represented by positive or negative shapes, depending on the relative background tone.

The background determines the choice of positive brushstrokes or negative spaces. The top half of this plant stands against a light background, so the leaves are fashioned from positive brushstrokes; lower down the background is dark, so the leaves are fashioned with 'negative' shapes.

This outline of Avignon was drawn without looking down and without taking the pen off the paper; it is surprisingly accurate.

Mist Rising Below Avignon
28 x 35.5 cm (11 x 14 in)
By keeping the eye on the city's skyline and quickly glancing down to the paper, a flat brush could be used to paint the silhouette with assurance and without any preliminary drawing at all.

Seeing and Drawing

The visual information needed for figurative painting is found in the physical inspiration. This means you need to hone your observational skills. Never presume you know what something looks like; you have never before seen it under this particular light.

The best way to train your observational skills is to practise contour drawing, and to do this without looking down at your paper. This may seem illogical at first, but you will be surprised how well you can draw something if you concentrate on the actual subject rather than the marks on the paper. Start on the left if you are right-handed and do not take the pencil off the paper until you reach the end of your chosen outline or you will lose your way and your sense of scale. Once you feel more confident drop the odd glance down to your paper to check the pencil is in the right position, then you can do more complicated drawing that requires you to lift your pencil off and reposition.

Soon you will realize that to make a painting you must continuously refer to the subject. It is impossible for the eye to hold the nuances of tone and colour needed for watercolour painting for very long, so you must keep returning your eyes to the subject to gain the information needed. To an onlooker you will look like a nodding dog on the dashboard of a car!

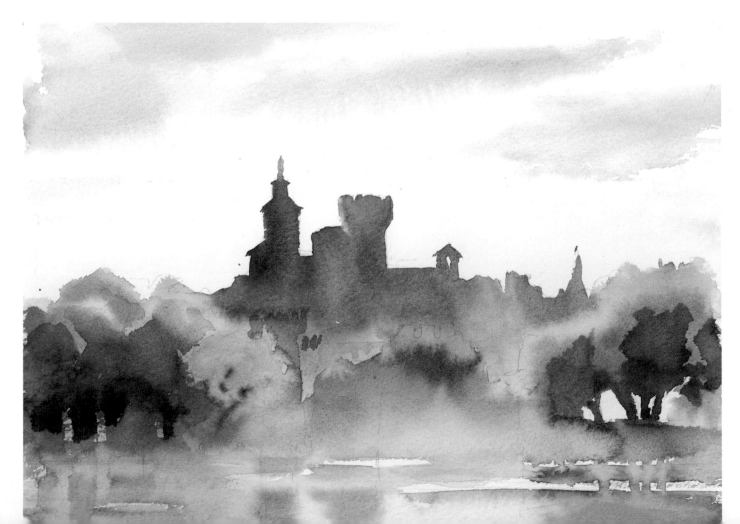

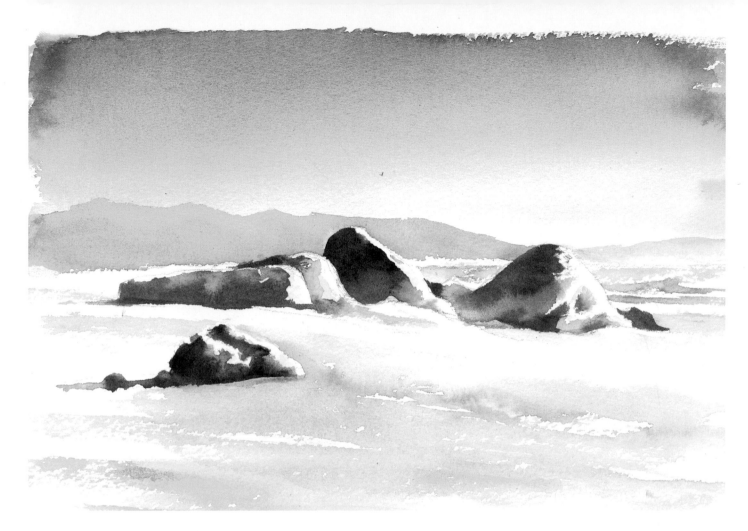

Rhythm Lines

Composition is the design of a painting on the paper and is usually made with the use of drawn lines. The rhythms of the lines establish balance within the boundaries of the picture space and direct the eye to the focus of the painting. As you observe your subject try to see the lines that would be useful to fulfil these functions, and ignore those that serve no purpose. Gradually you will start to recognize which views lend themselves to painting compositions by the leading lines and patterns inherent within them. You will realize that while everything can be painted, a view does not necessarily make a good painting unless it has compositional strength. Do not be surprised to find that sometimes the most picturesque subjects do not necessarily make good paintings.

Transfer of Time (Noordhoek Rocks)
28 x 35.5 cm (11 x 14 in)
The rhythm of the varied heights of the rocks and the balance of alternating light and shade make a satisfying composition.

A brief pencil sketch finds the rhythm of the composition in three simple flow lines coming together beside the ocean.

Crystal Arch
Salt crystals tossed into watercolour
Salt crystals offer a fun way to overrule the tendency to 'copy' colours. Paint a strong multicoloured wash and toss salt crystals into the wet paint. Let it dry completely and brush them off, then draw and paint the tonal structure on top of the variegated wash, criss-crossing the pattern made by the salt.

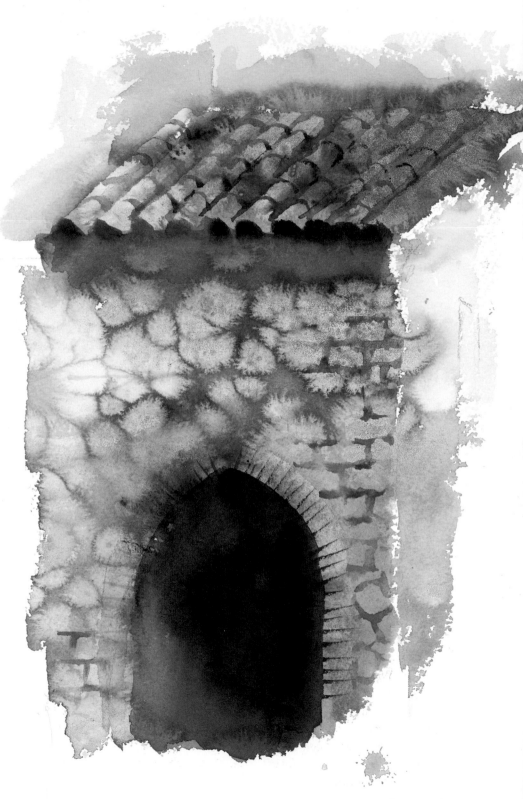

Changing Colour

While it is crucial to get your relative tonal values right it is not necessary to faithfully follow colours. Under any given light colours change, so no object has a set colour. In a painting the lit side of a feature will be a different colour to the shaded side, even if the object is monochromatic. All colour is relative, so it is the colour bias that is important to the painter. Learn to look for the relative warmth or coolness of a colour in relation to its neighbour and in relation to the whole. When observing your subject look for colours that pervade the whole or the majority of the view, and note where dark colours are lit and light colours are in shade. These are the kinds of decisions you need to practise for painting watercolour. Learning to see as an artist takes time and practise but the process is exciting and rewarding.

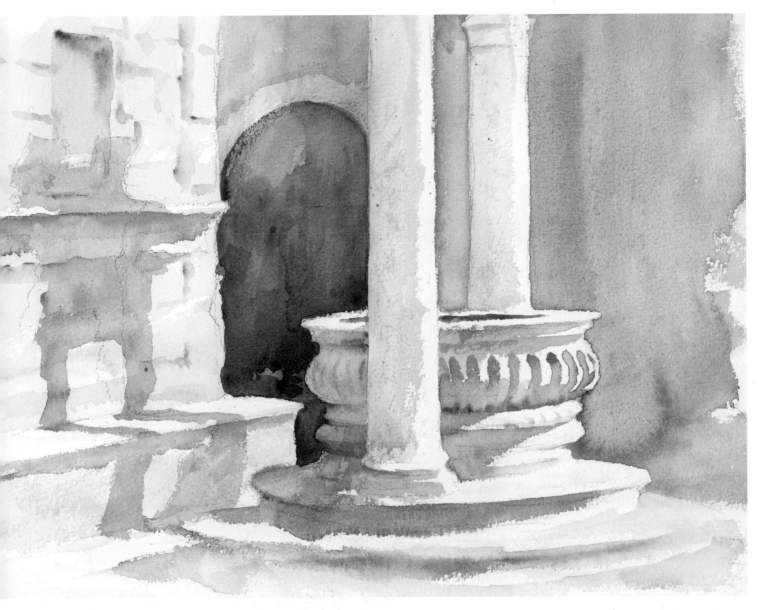

In the Zone

Watercolour, with its intrinsic characteristics and the need for decisiveness, is the perfect medium for a painter. Adrenaline may pump in the face of white paper and emotions can be on edge but the mind is centred, the body forgotten, the artist is living in the moment. Relax, this is bliss.

Watercolour may be an art but what is happening on the paper is science. If you can harness the properties of this wonderful medium and then give them plenty of freedom you will master the art. Concentration and patience are crucial, focus on planning, mixing, laying the right brushstroke, at the right time, in the right place … and then magic will happen.

Deep Heart of Pienza
35.5 x 51 cm (14 x 20 in)
Tones are relative to each other and to the whole. Here the door is the darkest part of the painting but it need not be painted as dark as it is in real life, it just has to be painted darker than everything else in the painting.

Gallery

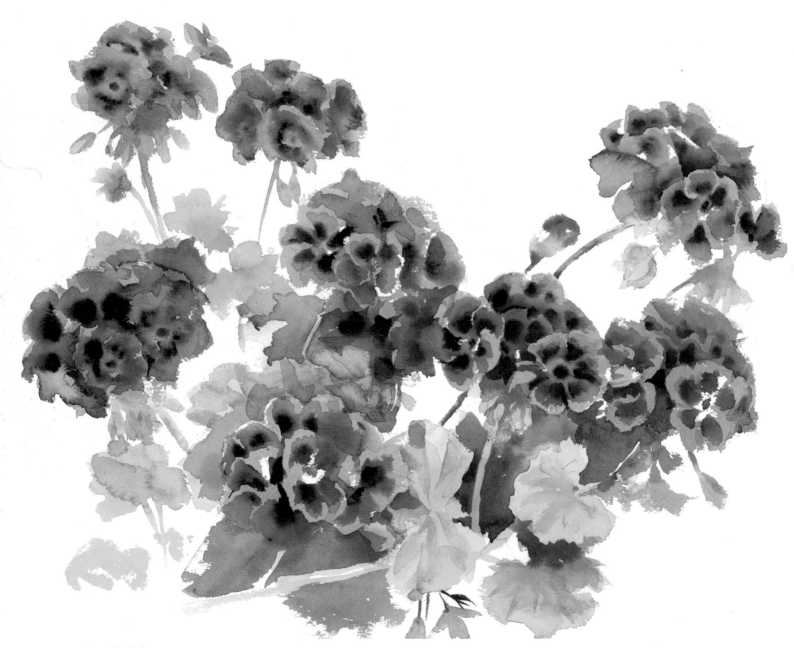

Drunk with Colour
46 x 56 cm (18 x 22 in)

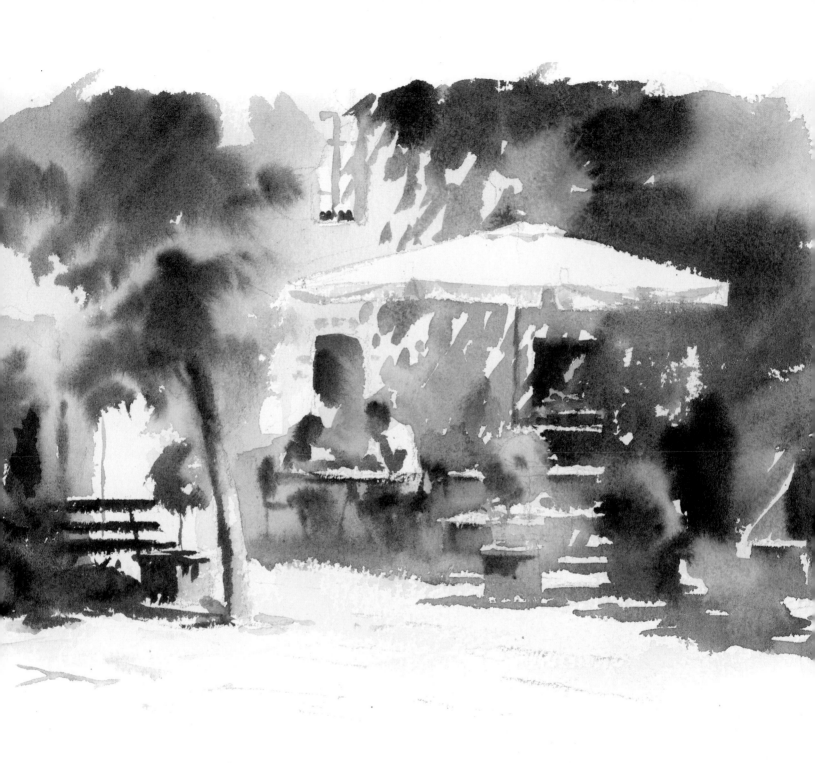

Drifting Through Tuscany
25 x 35.5 cm (10 x 14 in)

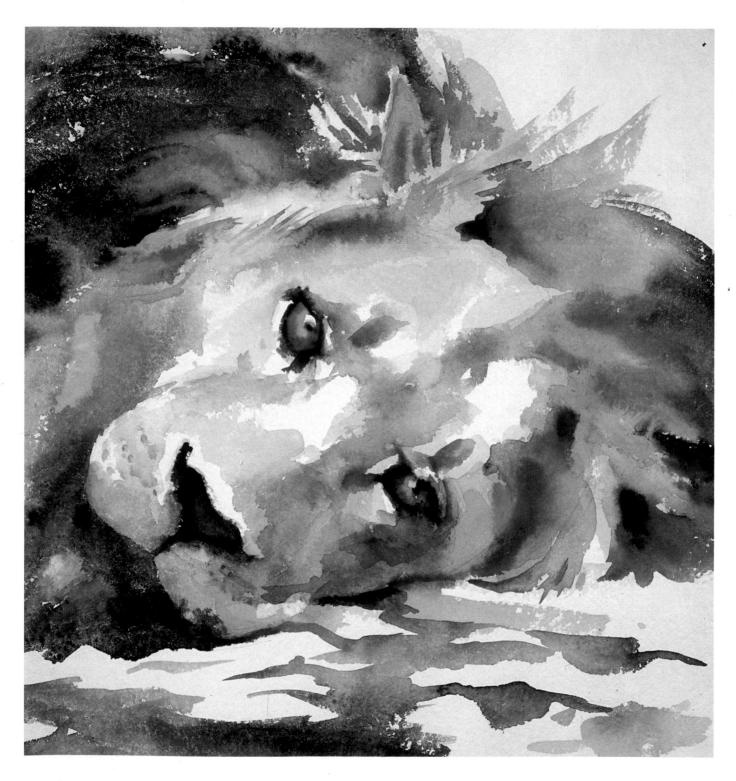

Lazy Lion
43 x 43 cm (17 x 17 in)

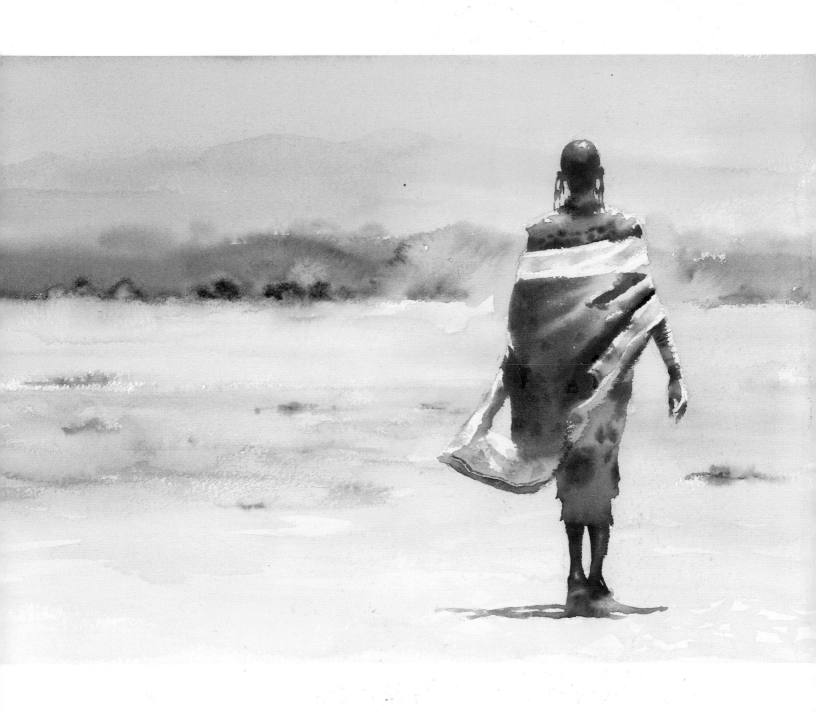

She Carries the Breeze
35.5 x 51 cm (14 x 20 in)

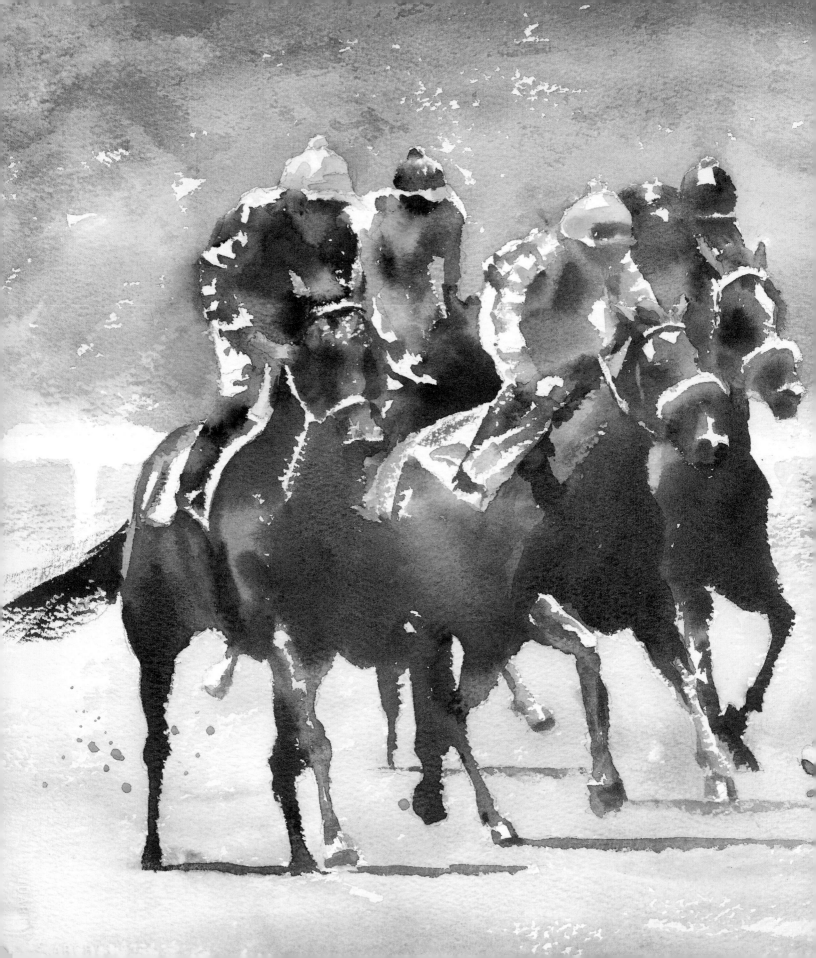

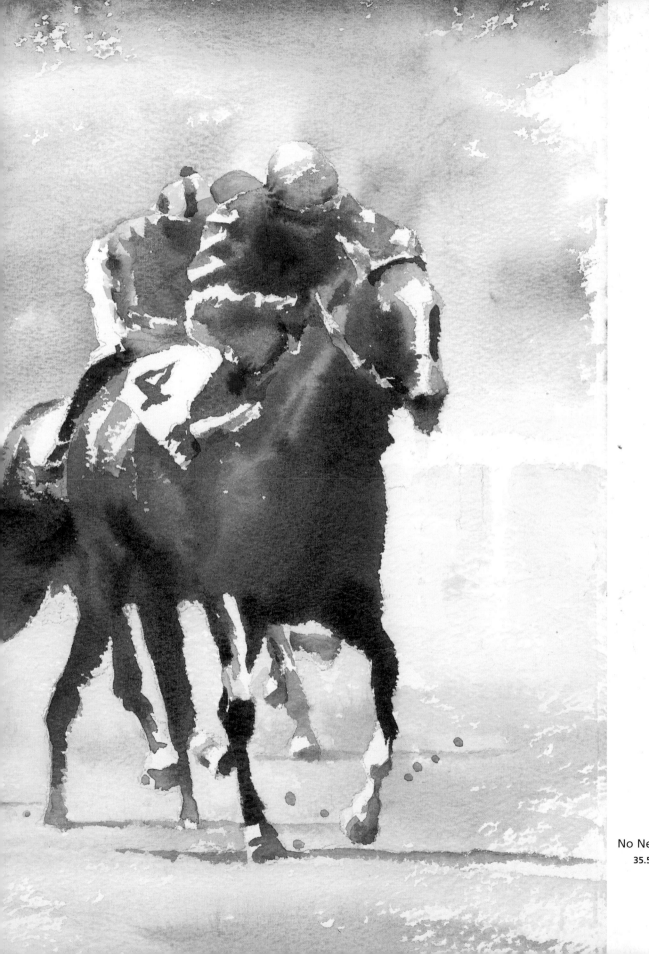

No Next Time Around
35.5 x 51 cm (14 x 20 in)

Index